HAMPTON ROADS

MURDER & MAYHEM

HAMPTON ROADS
MURDER & MAYHEM

NANCY E. SHEPPARD

THE
History
PRESS

Published by The History Press
Charleston, SC
www.historypress.com

First published 2018

Manufactured in the United States

ISBN 9781467140423

Library of Congress Control Number: 2018945675

This book is dedicated to those who have been victimized in their lives, the survivors and those whom we've lost along the way.

CONTENTS

CONTENTS

ACKNOWLEDGEMENTS

I would like to give thanks to the many people, organizations and agencies that helped bring this book together.

Thank you to my husband, Josh, for his ardent support of everything I do to bring history to page, to give life back to the forgotten and to continue to tell the tales that need to be told. Thank you for your research assistance and endless hours helping me edit. I love you dearly.

A special thanks to my beautiful children, Emory and Ben. Thank you for always being my cheerleaders and helping me see all the beauty and wonder in the darkness of this world. My love for the two of you runs deeper than I could ever explain.

Thank you to my parents, Jim and Robin Miller, and my sister, Jennifer Miller. The three of you have always been there to support me in chasing my dreams by attending my events, reading my drafts, providing necessary babysitting when I've had to work, always being there to love and look out for me. I love you all very much.

Thank you to my editors, colleagues and all the many readers of the amazing newspaper I work for, *Yorktown Crier-Poquoson Post*. Thank you for allowing me the platform to share so many stories in our community.

Thank you to Beth L. Crumley (assistant historian for the U.S. Coast Guard), Troy Valos (Sargeant Memorial Collection, Norfolk Public Library), Allen Hoilman and M. Séamus McGrann (Hampton History Museum), Frank Green (York County Historical Society), Peggy Haile-McPhillips (Norfolk Historical Society) and Susan Connor (*Daily Press*).

Thank you to my friend Dawn Midkiff for her insight, thoughts, support and endless delightful conversation.

Thank you to my team at The History Press, including Kate Jenkins and Hilary Parrish. You continue to take a chance on local authors like me and allowing us to share these rich and vibrant stories so that they are never truly lost.

A special thanks to "Team *ROMA*," who have been so supportive in my stepping aside from my lighter-than-air historical endeavors to pen this piece. I am so lucky to have found such a great "family" within the LTA community.

Finally, thanks to Marie Gringas, Aliya Redwine, David Wilson and Candice Elliott for helping me "organize my life." I am truly thankful for everything that you all do!

OPENING THOUGHTS

I t is the darkest moments that give definition and depth to an otherwise beloved region. Hampton Roads, which sits at the most southeastern corner of the Commonwealth of Virginia, is no exception. This part of the United States birthed our nation and is rich with a fascinating history of strife, struggle, life, love and loss. It is a fluid culture constantly struggling to find cohesion within the ever-changing landscape of American society.

This book is merely a glimpse into a handful of the darker episodes faced by and also as a result of experiences had in Hampton Roads. These are moments of murder, mayhem, scandal and mystery that defined the lives of those involved and left a lasting imprint on Hampton Roads' Edenic surface.

With the research that was available to me, I have compiled some of these moments for you to the best of my ability, while trying to stay respectful of those involved and true to the original source documents. I encourage you to not read each chapter and think of these as just stories but remember that these were the lives of real people who lived and suffered. Think of their names, picture them in your mind, feel the pain they felt and try your best to understand what they went through. Place yourself in their shoes and ask questions like, "What would I have done?" and "What if this happened to me?"

It is with these questions in mind that we embark upon this journey together with the singular mission to breathe life back into the people

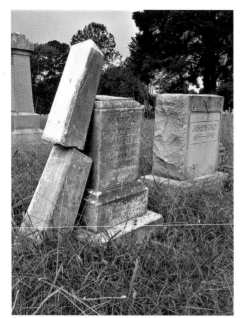

Left: Graves at Hampton's abandoned Historic Oakland Cemetery. *Nancy E. Sheppard.*

Right: Grave in Norfolk's St. Mary's Cemetery. *Nancy E. Sheppard.*

whose unfortunate defining moments are detailed in the following pages. Their stories are not for the faint of heart, but their legacies are deserving of remembrance.

After all, their stories could have been your own.

THE MASSACRE AT AJACÁN MISSION

York and James City Counties, 1540

For those living in the sixteenth century, the North American continent was the "undiscovered country." It offered European powers the possibility to acquire vast tracts of land and find new means of wealth, and most importantly, it was pivotal to the race for the elusive Northwest Passage. Many believed this passage would provide an accessible trade route to the riches of the Orient. The Spanish laid claim to the southeastern tip of this new continent, which they named "La Florida."[1] While they sent missionaries and conquistadors west for further exploration, they had their sights set on moving north. This is where they believed the Northwest Passage, which they called the "Strait of Anian," was located.

In 1561, renowned explorer Juan Menendez Marques was directed by the Spanish Crown to find the strait. Marques's galleon was sent off course by a fierce storm, leading his ragtag band of explorers into a previously unknown body of water, which they christened Bahia de Santa Maria (present-day Chesapeake Bay).[2] Marques was impressed by the bay's abundance of safe ports along the shoreline and plentiful fisheries in its deep waters.

He ordered his fleet to drop anchor so that they could explore the potential for natural resources ashore. A short distance inland, they encountered the native village of the Kiskiak people, a tribal member of the Powhatan Confederacy. As a seasoned explorer, Marques knew that in order to gain further success in the region, they needed a guide to act as an intermediary between the Spanish and native people. He traded what goods and riches he had for a young Kiskiak boy named Paquiquineo.

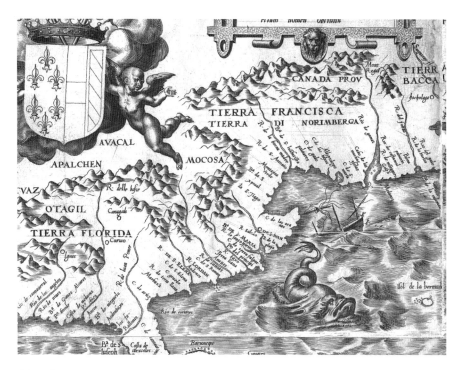

Diego Gutiérrez's 1562 map of La Florida. *Wikipedia.*

Marques pledged to return the boy to the village in a few years' time, along with an abundance of fine garments and wealth as payment to the Kiskiak.[3] Paquiquineo's exact identity has been the source of historical debate, with some experts theorizing that he was a son or nephew of the chief, while others arguing that Paquiquineo was Opechancanough, of latter Jamestown fame.[4] Whoever Paquiquineo was, his role in shaping the future of the new territory was crucial.

Marques took Paquiquineo back to Spain, where he was a welcomed guest at the court of King Philip II. The king was intrigued by the intelligent, enthusiastic young man. In 1562, King Philip II asked Paquiquineo to accompany an expedition to La Florida in order to expand Spain's territorial foothold in the New World.

En route, Paquiquineo fell violently ill. Fearing for his life, he begged the expedition's priest, Luis de Velasco, Viceroy of Mexico, to baptize him into the Catholic Church. He was baptized with the Christian name of Don Luis in honor of the priest.[5] By the time his ship arrived in La Florida, the newly baptized Don Luis had made a miraculous recovery.

The Spanish led several unsuccessful expeditions in vain attempts to retrace Marques's original voyage north. This allowed plenty of time for Don Luis to absorb his adopted culture while still acting as an ambassador between his hosts and La Florida's native people. Though it seems that he was treated fairly, Don Luis paid witness to the merciless violence that the Spanish inflicted on the native people they encountered. These memories were burned into his mind, convincing Don Luis that he needed to play the role that the Spanish expected of him if he wanted to survive.

While awaiting word from the expedition with Don Luis, a Jesuit priest in La Florida named Father Juan Baptista de Segura formulated a plan to perform missionary work in order to bring Catholicism to the natives living on the banks of Bahia de Santa Maria. He petitioned the governor, Admiral Pedro Menéndez de Avilés, to be able to lead the expedition north. Given the kingdom's thirst for continued expansion and an innate understanding of the potential profitability in just such a venture, the governor readily agreed to Father Segura's proposal.[6]

Father Segura asked several trusted, though untested, holy men to join him. The party included Father Luis de Quiros; Brothers Gabriel Gomez Sancho Zaballos and Pedro Mingot de Linares; lay catechists Cristobal Redondo, Gabriel de Solis and Juan Baptista Mendez; and Alonso de los Olmos, the teenage son of a Spanish colonist. The Spanish Crown insisted that Don Luis join the expedition as a translator between the clerics and his own people, with Father Segura expressing his personal desire for Don Luis to proselytize on their behalf in his native tongue.[7]

Despite heading into unknown, potentially hostile territory, Father Segura rejected any sort of military presence and support. He believed that any sort of armed presence would only serve to cause hostility, hampering their zealous conversion attempts.[8]

Father Juan de la Carrera was charged with obtaining supplies for the missionaries. He was critical of Segura's choice of such an inexperienced team and their lack of military protection. Segura requested chalices, vestments and other religious articles of great monetary value. Carrera argued with Segura, stating his fears that the native people would plunder the sacred items for their own gain. He also noted that Segura requested a very limited supply of food because he naïvely placed his faith in the charity of the native people for sustenance.[9] While en route to their destination, Segura shared the mission's limited food stores with the crew of their transport galleon. What Segura had no way of knowing was that their destination was in the midst of an unprecedented drought.

The natives were already suffering from food shortages and had very little to spare.[10]

In August 1570, the ship arrived at what is today named Kings Creek.[11] Don Luis guided the missionaries downriver towards Kiskiak so they could conduct trade with what little they had brought with them.[12] When they arrived at his home village, Don Luis's people celebrated his return. Father Quiros described the moment as though "Don Luis had risen from the dead and come down from Heaven."[13]

However, the Kiskiak hadn't forgotten what was promised to them upon the return of their native son. Without the garments and other riches Marques had pledged, the Kiskiak felt that their trust was broken. They resisted all prospects of trading with the missionaries, devastating Father Segura's faith in their aid. He mandated:

> *Take care that whoever comes here in no wise barters with the Indians, if need be under threat of severe punishments, and if they should bring something to barter, orders will be given that Don Luis force them to give in return something equal to whatever was bartered, and that they may not deal with the Indians except in the way judged fitting here.*[14]

Don Luis was overcome by a silent longing that sprang from years apart from his home. He kept his feelings quiet and compliantly left with the missionaries. After traveling a day and a half from the Kiskiak village, a site was chosen, and Don Luis helped the missionaries construct a makeshift shelter. Inside the small wooden structure was a room used for worship and another as shared living quarters. They named the mission Ajacán. Once the finishing touches were placed on the ramshackle mission, Don Luis asked to return to his village, pleading that he needed to visit an ailing sibling. Knowing that their food stores were already depleted and having no reason to distrust Don Luis, Father Segura gave his blessing with the caveat that Don Luis return in a few days' time with a resupply of food. Don Luis thanked Father Segura and disappeared into the woods. He left the missionaries alone in the unknown wilderness with no food or ability to defend themselves. All they had left to trade was a small amount of tar that the native people could use to patch canoes.

Days turned into weeks without any word from Don Luis. The following February, a desperate Father Segura sent three missionaries to bring Don Luis back from the Kiskiak village. Recognizing their dire situation, Fathers Segura and Quiros penned a letter to Spanish officials, expressing their

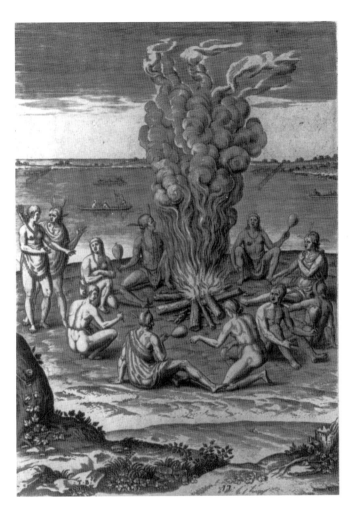

Engraving by
Theodor de Bry
(1528–1598).
Library of Congress.

desperate circumstances and pleading for additional supplies for both survival and trade.

What the missionaries had no way of knowing was that, upon his return, Don Luis had abandoned his Christianized identity, reclaimed his native name and was elevated as the tribe's chief. For the first time in a decade, he was surrounded by people who were able to defend him and that held a territorial advantage over the Spanish. He no longer had to fill the role expected of him by the Spanish just to survive. When the Jesuit priests arrived in the village, they were shocked by Don Luis's changed appearance and his cold nature towards them. The new chief rebuffed their demands for trade and requests to return with them.[15] When the missionaries continued to press with threats of violence, their former companion ordered their

execution. After the violent, gruesome slaying of the missionaries, he ordered the corpses stripped of their garments and ornaments.

Don Luis concocted a plan that would not only ensure the survival of his people but also assert his authority over his native land. He carefully selected a group of men, and they made their way to the mission. Upon arrival, Don Luis found Father Segura outside chopping wood. The priest was initially relieved to see his lost companion. "Don Luis! You are most welcome!" he exclaimed.[16] When Don Luis did not return his affectionate salutation, Father Segura dropped his hatchet and backed slowly towards the hovel. Don Luis walked steady towards the priest, grabbing the hatchet from the ground. In one swift, solid swing, he smashed the blade into Father Segura's skull before the cleric could even utter a noise.

Hearing confusion outside, the other missionaries ran from the shelter to find Father Segura's bludgeoned, lifeless body on the ground with the murder weapon in Don Luis's hand. Panic ensued as they fruitlessly pleaded for their lives. Alonso de los Olmos crouched beneath a table, trembling as he watched the missionaries cut down one by one, their bodies stripped of garments and adornments. After what felt like an eternity of slaughter, the mission fell silent. The only person in the mission to survive was Alonso. The Kiskiak plundered all of the expensive religious items and took Alonso captive, hoping to use him as collateral against the Spanish.[17]

By spring, a Spanish ship arrived in the bay to provide provisions for the Ajacán Mission.[18] Instead of eager missionaries waiting for them, they found a grisly scene of naked, decaying corpses with all of the mission's valuables missing. The native people arrived and attempted to lure the confused Spanish to their village. Fearing a trap, they denied the request and retreated to their ship. Later that day, the Kiskiak rowed canoes to the hull of the Spanish galleon. They underestimated the Spaniards' might and were vastly outgunned, with two high-ranking members of the tribe taken prisoner. Intense interrogation of the prisoners revealed details about the massacre at Ajacán in the months prior. Worse yet, the Spanish learned of Don Luis's betrayal and that Alonso de los Olmos had been taken captive. They sailed out of Bahia de Santa Maria to report their findings to the Spanish governor in Havana and to subject their prisoners to further questioning by higher authorities.[19]

In August 1572, they returned to Bahia de Santa Maria with a fleet led by Juan Menendez Marques, including four warships carrying approximately 150 soldiers. Their goals were to rescue Alonso, assert their assumed superiority over the natives and to seek justice for the fallen missionaries.[20]

They rowed ashore at modern College Creek and marched to the Kiskiak village. They found the native people wearing clothing and other valuables that once belonged to the fallen priests of the Ajacán Mission. To add insult to injury, one man had fashioned a communion plate into a neck ornament. The Spanish soldiers were infuriated and engaged in a violent skirmish with the Kiskiak, which resulted in the deaths of 20 native people and the capturing of 13 more.

Marques demanded that they return Alonso and hand over Don Luis. When the Kiskiak did not comply, he hanged nine of the prisoners from the flagship's rigging.[21] Again, Marques demanded Alonso's safe return in exchange for the remaining prisoners. The Kiskiak reluctantly complied and handed the boy over to Marques. When Alonso was safely on board Marques's ship, the traumatized young man could barely remember how to speak his native tongue. Alonso offered very little detail regarding the horrors he experienced while in captivity.[22] Marques took one final act of vengeance and hanged the remaining prisoners.

The Spanish continued to remain a presence in Bahia de Santa Maria in order to access the bay's abundant fisheries. However, they abandoned all attempts of land settlement by 1573. When the rest of the Powhatan

A view of the York River. *Library of Congress.*

Confederacy learned of how the Kiskiak were betrayed by the Europeans, they built up their defenses and developed negative notions towards all outsiders. When the English arrived to establish Jamestowne in 1607, the Powhatans were ready for any danger the English brought with them.

DUE TO THE LACK of artifacts and evidence, the exact location of the Ajacán Mission has never been discovered. Historians and archaeologists believe that it was somewhere between modern Yorktown Naval Weapons Station and the original 1607 Jamestowne Settlement.

In 2002, the Richmond Diocese of the Roman Catholic Church opened cause for the canonization of the Ajacán missionaries, presenting an argument that the men were martyred for their faith. Limited by only the accounts written by the "martyred" missionaries and with no confirmed miracles tied to them reported to the church, the case remains open.[23]

Don Luis evaded capture and disappeared into the ethers of history. An eighteenth-century Pamunkey Indian written account suggested that Don Luis and the later Powhatan chief Opechancanough were one and the same person, but there is no way to prove the validity of this claim. What cannot be argued is that, had it not been for Don Luis betraying the Spanish priests, Virginia could have ended up a far different place with a very different history.

CANNIBALISM AT JAMES FORTE

Jamestown, 1609-1610

To the archaeologists, anthropologists and historians who have studied her, she isn't an artifact. She's "Jane"—a teenage girl with her entire life ahead of her; she probably had a happy, though unmarkable childhood in her native England and never faced any incredible hardship until the very end of her life. When she died, she suffered in ways that seem impossible to understand. She was helpless as her neighbors and loved ones starved or died from the mysterious diseases that ran rampant throughout James Forte. Then either by starvation or disease, Jane succumbed herself. Before her corpse was cold, she was butchered—hacked apart in an act of desperation so that perhaps in this girl's death, others might live.

But her name wasn't actually Jane. Jamestown Rediscovery Project gave the moniker to the discovered skeletal remains of an unknown girl. She was found tossed into a Virginia Indian pot with other refuse from the earliest years of James Forte, left to waste away in the basement of archaeology site Structure 191.[24] Archaeologists uncovered her teeth, remnants of her skull and a mutilated piece of her shinbone.

What was left of this young woman was sent to a laboratory for further analysis. The bone fragments told the story of an unknown fourteen-year-old girl from a well-to-do English family who hadn't been at Jamestowne very long before she died.[25] Through a series of CT scans, digital recreations and 3-D printing, the face of this long-lost girl, whose remains laid abandoned for nearly half a millennium in silence under two and a half feet of dirt,[26] was brought back to life. Looking into the hollow eyes

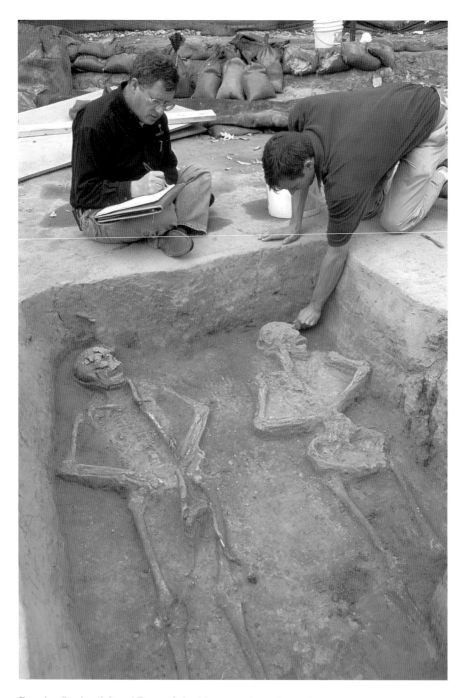

Douglas Owsley (*left*) and Danny Schmidt excavating at James Forte. *Wikimedia.*

of this facial reconstruction barely scraped the surface of the secrets that she had yet to reveal.

Her body wasn't lovingly buried, like one would expect of someone with her status. What was found of her was entombed with trash and animal bones. There were tool marks along the exterior of her mandible and forehead, her head was cracked open by some sort of blunt instrument at her left temple and there is evidence that a second, far more skilled butcher took over the grisly task of butchering her leg at the knee. "Jane" was the first true evidence of the survival cannibalism only previously rumored to have occurred at the Jamestowne colony during the winter of 1609–10, in a period better known as the "Starving Time."[27]

Jamestown (or "Jamestowne") was founded on May 13, 1607, by the English joint stock company, the Virginia Company of London.[28] Captain Christopher Newport sailed from England with 104 male colonists on board the ships *Susan Constant*, *Discovery* and *Godspeed*.[29] The initial purpose of the colony was to create saleable goods and commodities in order to repay the company's investors while, in turn, placing a permanent footprint in the New World for the English. Their long-term goal was to turn the venture into a profitable one. The Virginia Company of London advertised its new colony as an Edenic paradise, with plenty of gold, an abundance of resources and food, where crops readily grew with little effort.[30] Only a handful of the original 104 colonists were accustomed to the hard, labor-intensive agrarian lifestyle that would be required of them in the New World.

The new colony sat on a peninsula (now an island) surrounded by the brackish James River and the Pitch and Tar Swamp. Without an easily accessible source of drinkable water, considerable time was spent searching for freshwater aquifers. Though they assumed that relief was found from the wells they dug, the colonists had no way of knowing that the water they drank was naturally laced with dangerous levels of arsenic. This was a natural occurrence in this particular water source, with arsenic levels varying greatly due to temperature variations and the flow of the James River. Given that the region was still under the same drought that affected the Ajacán Mission (see chapter 1), the weather remained at above-average temperatures, thus raising the arsenic levels considerably. Colonists reported experiencing mysterious symptoms like skin peeling, "bloody flux" (bloody diarrhea) and mysterious, sudden death—all symptoms consistent with arsenic poisoning.[31]

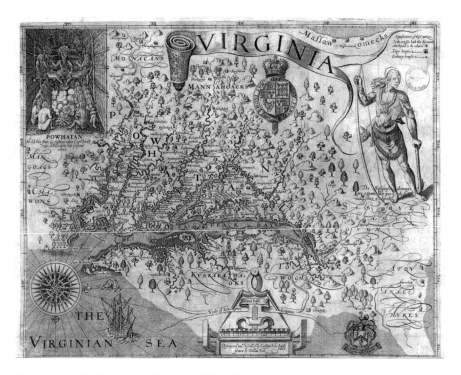

Captain John Smith's map of Virginia. *Wikimedia.*

To add to the colony's burdens, the seven-man body chosen to locally govern was far from harmonious. The men were often attempting to "outdo" one another in grabs for power instead of focusing on the productivity, sustainability and survival of Jamestowne. Colonists also blamed Sir Thomas Smith, the chief executive of the Virginia Company of London, who asserted his authority over a colony he had never been to.

Reports from the colony's governing body showed their mutual feelings towards the colonists. In one report, the colonists were described as having the attributes of "idleness and bestial sloth of the common sort, who were active in nothing but adhering to factions and parts, even to their own ruin."[32] Councilman Thomas Gates wrote that he witnessed men eating raw fish instead of making an effort to fetch firewood for cooking.[33] They often refused to sow their own crops, perhaps because they didn't know how, and became entirely reliant upon their indigenous Powhatan neighbors for survival.

However, the fault does not lie squarely on the colonists' shoulders. The Virginia Company of London was desperate to pay back its investors while

still trying to keep the company afloat. It placed an undue amount of stress on the colonists to procure saleable goods as priority over making adequate repairs to structures and growing and storing enough provisions for their *own* survival. Though the gold the company promised was never discovered, there was a bounty of wealth in timber that the colonists found in abundance around Jamestowne.[34]

References to starvation were mentioned as early as 1607 in a report sent to the Virginia Company of London, compiled by the "Ancient Planters Nowe Remaining Alive in Virginia" ("Ancient Planters" meant "First Colonists"). They reported the challenges they faced, the diseases they endured and the starvation that persisted in the colony. By the end of the first nine months of the colony's life, only thirty-eight of the original settlers survived, with most of the victims having succumbed to starvation or disease.[35]

The following year was fraught with similar challenges. Captain Newport returned to Jamestowne with two supply ships, but soon thereafter, the colony caught fire, and most of their equipment and possessions were destroyed. The colonists at Jamestowne were left with only fourteen broken nets, and without the knowledge to repair them, they were forced to fish without any adequate tools. When Newport returned to England, he took Sir Thomas Gates back with him. That September, John Smith took over leadership of the colony's council. He was an unlikable man, known for his strong-armed tactics with the Virginia Indians, whom the colonists referred to as "savages." He persisted with trade negotiations, but cordial interactions quickly turned hostile between the two groups.

At the beginning of 1609, John Smith split apart the colonists, sending one group of men down the Nansemond River, a second to what is known today as Old Point Comfort in Hampton and the third near the outskirts of modern-day Richmond. Smith believed that this would not only widen the colony's trade net but also allow for the gathering of more food for the mother colony. Meanwhile, he reported to the company that forty acres of land were cleared around James Forte, twenty cabins and a blockhouse were built, a well was dug, the church was reroofed and a new fort was erected across the river from the main colony.[36] Not everything was as well-functioning and tidy as Smith made it out to be.

Back in England, the Virginia Company of London received a second charter, which installed Sir Thomas Gates in place of Smith as president of the colony. Additionally, the company prepared a new wave of colonists to join the others at Jamestowne, including a certain number of women and children (whose names were not registered on any documents). In early

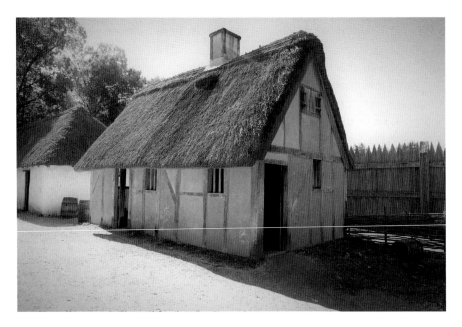

Reconstruction (located at Jamestown Settlement) of a typical dwelling in James Forte. *Nancy E. Sheppard.*

June 1609, a fleet carrying five hundred soldiers, women, children and an abundance of supplies set sail for Jamestowne. It was on one of these ships that "Jane" left her home for an uncertain future in the New World.

On July 23, 1609, the flagship, *Sea Venture* (which contained the vast majority of the supplies), was caught in a three-day long hurricane and its crew, passengers (including Gates) and supplies were marooned in Bermuda.

By August 11, *Swallow*, a smaller ship in the resupply fleet, had limped into the James River. With onboard food stores rotted and many passengers ill, the fledgling colony was unable to immediately absorb its new members. Smith ordered the new colonists to set up camp in their seven-acre cornfield. Within three days, the field's corn was depleted, leaving nothing in their stores for the impending winter.[37]

In September, John Smith was gravely injured in a freak explosion, forcing him to return to England. This left George Percy as the interim president of the colony. Smith's departure coincided with the abrupt ending of trade relations with the Powhatan people. The natives destroyed approximately six hundred of the colony's hogs and cut loose the few small boats they had left for fishing.[38] Following Smith's lead, Percy split the colony into three more parts. He sent colonist John Ratcliffe to lead fifty men to the Powhatan in

26

a desperate attempt to force trade between the peoples. Weeks later, only sixteen of the men returned to Jamestowne. They told Percy a terrifying story of what had happened to John Ratcliffe. The Powhatan tortured Ratcliffe, flaying and burning him alive. The sixteen men were sent with a message from the chief: if any colonist dared to venture beyond the fort's palisades, he or she would be killed.[39]

George Percy was desperate but knew that any chance they had to rebuild relations with local tribes were futile. He sent Francis West and thirty-six men north aboard *Swallow* to trade with the Potomac Indians. West's journey proved successful, and the stores of the vessel were filled with enough corn and goods to make it through the winter.

In November, three hundred colonists crowded into the palisades of James Forte. Their food stores were bare, with diseases and starvation quickly killing those huddled inside. Death was an unavoidable sentence for all those trapped inside the palisades. George Percy wrote, "Now all of us att James Towne beginneinge to feele that sharpe pricke of hunger wch no man trewly descrybe butt he wch hath Tasted the bitterness thereof A worlde."[40]

A few desperate colonists attempted to leave to search for meager sources of sustenance, such as roots, plants and small rodents. The neighboring tribes made good on their promise, and all those caught outside were immediately killed.

Jamestowne's only hope for survival lay in the hands of Francis West, his crew and the newly acquired supplies on board *Swallow*. After arriving back onshore, West heard rumors about the terrible conditions inside James Forte. In what could be perceived as either fear or cowardice, he decided that his crew would not die alongside their fellow colonists. He ordered the ship to sail to England, taking all of the supplies with them. And with that, any hope of salvation for those left at Jamestowne was lost.[41]

The starving colonists systematically butchered the animals inside the fort: first the horses, then dogs, cats, black rats and squirrels. Once all of the animals were gone, they ate tree bark and shoe leather. Desperate with hunger, they stared a grim fate in the face. They turned to their only readily available food source for survival: one another. George Percy wrote of one unnamed colonist: "And amongst the reste this was moste Lamentable Thatt one of our Colline murdered his wife Ripped the child out of her woambe and threw itt into the River and after chopped the Mother in pieces and salted her for his foode."[42]

The unnamed man was said to have butchered his pregnant wife's body, salted her meat and hid what was left throughout his hovel. Upon

Sidney E. King's artist rendition of the "Starving Time." *National Park Service.*

discovery, Percy determined that the man murdered his wife and ordered him tortured. He was hanged by the thumbs, with weights attached to all of his limbs. Within fifteen minutes, he confessed to cannibalizing his wife, though he maintained that he hadn't murdered her. Despite his protests of innocence, Percy found him guilty. He knew that he needed to send a strong message in these desperate times: murder of one another for food was not to be tolerated. The man was sentenced to a very public immolation.

But for those who died of disease or starvation, a blind eye was turned. Percy wrote:

> *Haveinge fedd upon our horses and other beastes as longe as they Lasted, we weare glad to make shifte with vermin as dogs, Catts, Ratts and myce… as to eate Bootes shoes or any other leather….And now famin beginneinge to Looke gastely and pale in every face, tthat notheinge was spared to mainteyne Lyfe and to doe those things which seame incredible, as to digge upp deade corpses outt of graves and to eat them. And some have Licked upp the Bloode which hathe fallen from their weak fellows.*[43]

It is unknown how "Jane" died, but it can be surmised that it was probably through the same means as her fellow colonists and that she was left without family to bury her. For those desperate for sustenance, her body was no longer seen as belonging to a person but as a means for survival.

Following her death, "Jane" was laid on her back, and an unknown individual hesitantly sheered at her forehead to remove the skin. When the butcher was unsuccessful for whatever reason, her body was turned facedown. The butcher cut along her mandible and right maxilla to remove her cheeks. Then, a blunt instrument was used to pry open her skull to remove her brain from its cavity. A more experienced, deliberate butcher stepped in to take over the grisly task of removing muscle and tissue from her legs.[44] What was left of "Jane's" body was tossed aside with the rest of the refuse.

Percy later described in graphic detail what he witnessed at James Forte: "Lamentable to behowlde them for many throwe extreme hunger have Runne out of their naked bedds being so Leane that they Looked Lyke Anotamies Cryeinge owtt we are starved."[45]

While no other evidence has been discovered to the contrary, it is doubtful that "Jane" and the unnamed pregnant woman were the only instances of survival cannibalism in the colony that cold, cruel winter.

ON MAY 22, 1610, the marooned crew and compliment of *Sea Venture* finally arrived at James Forte. The sight that beheld Thomas Gates was one that horrified him. Of the three hundred colonists who had been forced into the palisades the November before, only sixty survived. They were unfathomably weak, thin and ill. The grounds of the fort were littered with refuse, and the land was no longer tenable. After Gates shared what food they brought, Percy briefed him of the horrors that had occurred in the months before. Gates decided that their best and only option was to abandon the colony and sail back to England. On June 7, 1610, the remaining colonists loaded on board Gates's ships and set sail. They believed that the nightmares they had experienced were about to be left behind in the New World.[46]

En route, Lord de la Warr, the first chosen governor of Virginia, intercepted the ships and ordered them to return to Jamestowne. When they arrived, Lord de la Warr was taken aback by the condition the colony was left in with limited understanding for what they endured. He ordered it cleaned and prepared for an impending war with the Powhatan.[47] Under absolute rule, Lord de la Warr was determined to make this colony not only permanent but profitable. It was during the cleanup that "Jane" was more

Memorial for the victims of the "Starving Time." *Nancy E. Sheppard.*

than likely deposited into the cellar, never to be thought of again until she was discovered in 2012.

Between 1607 and 1625, 4,800 of the 6,000 total settlers died at Jamestown, primarily from disease, starvation or murder by the native people. Despite the devastating statistics and the odds stacked against them, the English managed to secure their first permanent footprint in the New World.

Today, Historic Jamestowne National Park is an active archaeological site. Buildings have been carefully mapped out and foundations restored. At the far end of the property, a building named the Archaearium was opened by the Jamestown Rediscovery Project, a subsidiary of Preservation Virginia. Inside the museum, visitors can gaze upon numerous artifacts that have helped tell the stories of those who lived at Jamestowne. In a dark corner of a far room, the reconstruction of a gentle teenager's face sits beside a small skull as she eternally stares through her black, cavernous eye sockets. Though we may never know her true identity, she will always be "Jane"—*our* Jane—the girl whose death may have saved others and whose legacy has given us a better understanding of the horrors endured by our forefathers at the first permanent English settlement in the New World.

THE WITCH OF PUNGO

Princess Anne County (Virginia Beach), 1706

Her statue stands on a street named for her legacy on the corner near Sentara Bayside Hospital and Old Donation Episcopal Church. She clutches a basket of herbs while a racoon looks lovingly at her. The woman depicted in this statue is Grace Sherwood, Virginia Beach's most beloved folk heroine. Her reverence was garnered in a most unexpected way, especially for a city known as the home for a popular nationwide Christian media company. Why? Because Grace was a convicted witch. She is beloved not because she actually was one but because she is an enduring image of feminism in a time when women had few rights and independence. She rebelled against an institution that defined women as subservient and meek and a society that turned against her because she was strong-willed and forthright. Grace Sherwood was fearless for not allowing her world to define her but defining herself to the world.

VIRGINIA'S HISTORY WITH WITCHCRAFT differs from its New England brethren. This was in part a result of Virginia having been founded as a profitable venture, whereas the Massachusetts Bay Colony was for religious freedom for the Puritans.[48] There was a healthier dose of skepticism in the Virginia Colony than in Massachusetts Bay towards the validity of claims regarding supernatural beings and occurrences. This could be attributed to the religious literalism versus superstition that existed more so among Puritans than in Virginia's Anglicans. Court cases in Virginia were heard by secular justices,

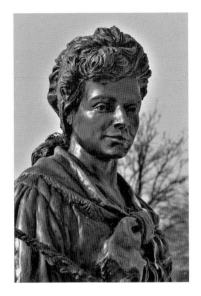

Statue of Grace Sherwood located in Virginia Beach. *Nancy E. Sheppard.*

unlike the cases in New England, which were fraught with clergy.[49] Whatever the reason for the deviations between the two colonies' systems of judicial practices, it must also be noted that Virginia didn't experience the same turbulent tide of accusations regarding witchcraft as was evident starting in late seventeenth-century Massachusetts.

The world experienced by early colonial Virginia women was quite different than what is felt here today. It was illegal for women to be landowners; thus, they could not represent themselves in court. A woman's husband was held entirely responsible for her being and actions. Only in civil suit cases involving defamation and slander was a woman allowed to be a co-plaintiff with her husband. These cases were usually brought to court when a woman was accused of sexual innuendo or witchcraft.[50]

Witchcraft accusations had early roots in the Virginia colony. In 1626, a woman from Kecoughtan named Joan Wright was accused of having supernatural inclinations. She was the earliest recorded criminal case of witchcraft of any English person in the colonies.[51] Joan was a local midwife and was accused of causing the death of a neighbor's infant child while also accurately predicting the deaths of three neighbors. One man accused Joan of bewitching him by stating, "[Despite] having very fayre game to shute… he could never kill any thinge."[52] To add insult to injury, Joan's neighbor accused her of bewitching her to dance naked and stand in front of a tree.

All of these scrupulous accusations are quite befuddling, if not amusing, when looked at through a twenty-first-century lens. Unfortunate as it was, infant mortality rates were quite high in the early seventeenth century, especially in the New World's frontier. Additionally, it was an unfounded allegation to thrust at Joan regarding her accuracy in predicting the deaths of her three neighbors. As stated in the previous chapter regarding the Jamestowne Colony, illness and other circumstances that caused unnatural deaths weren't out of the ordinary. Since Joan was a skilled midwife, she would have been able to recognize signs of impending death. Additionally,

Joan wasn't at fault for one neighbor being a poor hunter or for the other neighbor's rather scandalous inhibitions.

Fortunately, Joan was acquitted of all charges and went down in history for not only being the first person criminally tried for witchcraft in Virginia but also for being the first Englishwoman in the colonies to defend herself against those charges. English law stated that if a person was found guilty of witchcraft, the first charge would result in a year imprisonment, but a second would result in death by hanging.[53] If Joan was found guilty of all charges, she would have met the hangman's noose. Thankfully, she did not and was able to quietly return to her life.

WOMEN WERE FAR MORE likely to be accused of witchcraft than men. This was due to societal values and the expectations of a woman's role in the patriarchal, conformist society they lived in. Those governing the Virginia Colony wanted to deter the potential for an onslaught of false witchcraft accusations in order to avoid a similar fate that awaited New England. A fine of one thousand pounds of tobacco could be levied upon anyone who brought an unsubstantiated legal complaint of witchcraft before the local municipality's court. As an additional deterrent, if it was a woman bringing the false accusations, her husband had the ability to choose to either pay the fine or have his wife punished through public ducking.[54]

For colonials, reputation was *everything*. If they stepped even the slightest bit out of line with what society expected of them, they faced an uncertain future at the hands of their neighbors. In a sense, living in colonial Virginia was a seventeenth-century panopticon. Understanding the ramifications of a damaged reputation, the colonial government decreed: "Whereas divers dangerous & scandalous speeches have p[er] sons concerning sevrall women in this Countie, termeing them to be Witches, whereby theire reputacons have been much impaired."[55]

In 1671, Adam Thoroughgood II brought from England to Princess Anne County, Virginia, a series of law books, including Michael Dalton's *The County Justice*. In his book, Dalton details very specific instructions of how to determine the guilt of an accused witch and how the courts should proceed with prosecution. He places heavy emphasis on the necessity of physical evidence to prove witchcraft. This could include items from the home that could be interpreted as ingredients for magical spells and potions, such as hair clippings, animal bones and herbs. Also, bodily deviations were taken into consideration. Skin irregularities, such as moles or skin tags

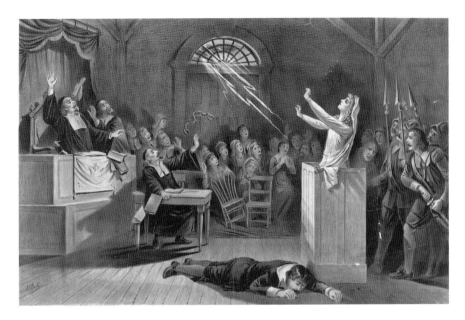

J.E. Baker's *Witch No. 1. Library of Congress.*

resembling teats, were thought to be telltale signs of witchcraft and called "witch's marks."[56] If a physical inspection was deemed necessary, the court retained an all-female jury to examine and report back its findings. This was an effort to maintain the accused woman's dignity and modesty. These same female juries were also used to inspect a woman's body in cases of pregnancy through adultery, bastardy or fornication.

Dalton's methodology was based in part on a pamphlet published in 1647 by famed English "witch hunter" Matthew Hopkins. In his pamphlet, Hopkins describes a method to employ the use of trial by ducking in the determination of whether or not a woman was a witch. According to Hopkins, the accused woman would be taken to a body of consecrated water, bound and thrown in. If she floated to the surface, she was a witch because the consecrated water was purging evil from it. If she sank, she was not a witch. It was not common for a mid-seventeenth-century English person to even know *how* to swim, thus making a person surfacing that much more mystifying to witnesses. The downside of Hopkins's "logic" was that if a woman sank, she would drown and die. Either way, the accused was losing everything. While non-deadly ducking was prescribed into law as punishment for the aforementioned "scandalous speech" in 1662, it had yet to be used in cases of witchcraft in the Virginia Colony.

Joan Wright was the first of several accused of witchcraft in Virginia. In 1655 (prior to the laws and recommendations from England), William Harding was a rare instance of a Virginia male accused of witchcraft. Whatever evidence was used against him has been lost, but he was found guilty, sentenced to ten lashes and then subsequently banished from the colony.

While witchcraft was quickly disappearing from the forefront of minds and morals of those in England (with the last English witchcraft-related execution recorded to have occurred in 1685), the still fledgling colony kept it in the proverbial back pocket as a scapegoat for less than culturally acceptable behavior to tarnish that person's reputation or to be used against someone from whom a neighbor or governing body wanted to gain something. An example of this occurred in 1698, when John and Anne Byrd sued for defamation over a prior accusation of witchcraft. Despite having all of the evidence in their favor, the jury dismissed the suit, thus passively stating that it tacitly endorsed the claim of witchcraft against the couple without any sort of evidentiary merit.[57] Colonists continued to remain a juxtaposition to the intellect that was teeming around them, with superstition rotting the core of their societal sense of morality. They even went so far as to place vials at the entrances and foundations of their homes that were filled with pins or nails. They believed that these charms would harm any witch who dared to place a curse on the structure or the people inside it.[58]

OBVIOUSLY, FEMINISM AND FREEDOM of thought were not attributes of the world that Grace Sherwood was born into in 1660. Born Grace White, she was the daughter of John White, a literate carpenter living in what is known today as rural Pungo in Virginia Beach. Her childhood was pretty unremarkable and in line with societal standards. She was an active member of the Lynnhaven Parish and considered in good standing. She grew into a beautiful young woman with brown eyes and dark hair.[59] Though quite intelligent, Grace was not considered literate. In 1674, her father received a patent for 195 acres of land in an area documented as the "Northern branch of Curratuck."[60]

In 1680, Grace married James Sherwood, who was considered illiterate (so much so that he wasn't even able to sign his name) and unskilled and was not bonded by land. By that era's standards, Grace was marrying below her status, thus earmarking her for the ire of her community. After the couple's marriage, John White transferred fifty acres of land to his new son-in-law,

who became a "planter" by trade. Despite the community's reception of Sherwood, John White was certainly fond of his only surviving child's husband. In his last will and testament, John decreed: "Soule to Almighty god and to Jesus Christ by whose death and passion I hoope to have Remission of all my sines…Loving sone In Law James Sherwood."

Upon John White's death, James was named sole executor of his estate. The Sherwoods inherited the entirety of the White estate, with the exception of some livestock and what was listed as John's "great gun."[61]

The Sherwoods differed from other members of the parish who had similar landholdings. They did not own any slaves, and James never held a position of public trust, while Grace served the community as a midwife and healer. She was often seen wearing men's trousers while she collected indigenous plants and herbs that she used for medicinal purposes. She was assertive, outspoken and wildly independent. James never discouraged his wife's behaviors or her personality. But these attributes were threatening to the patriarchy, while her beauty intimidated other women.

It was only a matter of time before the community turned against the nonconformist couple. In 1698, James and Grace sued parish member Richard Capps for defamation and sought £50 sterling. That same year, they also sued the Gisburnes and Barneses for defamation. The accusations in the latter two cases were far more slanderous, and they sought £100 sterling for reported damages. Both couples had spread slanderous rumors that Grace possessed some sort of supernatural powers or dabbled in witchcraft. In the case of the Gisburnes, they claimed that Grace bewitched their crops and used her alleged "powers" to kill their pigs. The accusations made by the Barneses were far more radical. Elizabeth Barnes, a well-respected member of the parish, claimed that Grace snuck into her home and rode on top of her as though she were a broomstick or horse before transforming into a black cat and slipping out through a keyhole.

These lawsuits were great examples of how reputation was everything in the community. Despite the Sherwoods presenting witnesses to testify to Grace's good character,[62] the council did not find in favor of the Sherwoods, thus dismissing the lawsuit. Like the Byrds decades earlier, this was the council's way of tacitly endorsing claims that Grace was indeed a witch. As a result, Grace's reputation was tarnished in the parish in which she was officially still considered a member in good standing.

In 1701, James died without leaving a will. Prior to his death, he sold fifteen acres of his land to Captain Plomer Bay. Without a will, ownership of the remainder of his property was left in limbo. Unlike what was expected of

women at the time, Grace refused to remarry in order to maintain her legal and societal status by way of a husband. Only one of the Sherwoods' three sons was of legal age at the time, but he refused to claim legal ownership of his father's property. Despite the odds against her, Grace asserted control of her land. However, neither Grace nor her sons ever received a clear title to the land after James's death. In 1704, a warrant was issued, and the land's patent reverted to the Queen. The only exception was thirty-five acres that were transferred to James Sherwood Jr. There isn't proof that Grace was ever ordered to leave her home or stop working the land.[63]

In December 1705, Grace brought a lawsuit against her neighbors, Luke and Elizabeth Hill. She sued them for £50 sterling, claiming that Elizabeth had "barbarously beaten" her.[64] She managed to convince the jury of her injuries, but instead of awarding her the judgment she sued for, they handed down judgment that the Hills were to pay a paltry 20 shillings—once again, a passive-aggressive, colonial Virginia adjudicated way to speak volumes of the joint opinion regarding the eccentric widow. The jury's foreman, Mark Powell, scrawled, "*Omitted to signe*" instead of his name on the decision, thus invalidating the verdict. Though the court issued an order for Powell to return the following month to validate the verdict, it was never enforced, and Grace was never able to collect on her reward.

Luke Hill was faced with a predicament. Not wanting his wife's reputation ruined in the community but also not wanting to face the prospect of having to pay even the smallest amount to Grace, he did something that would leave a lasting stain permanently affixed to Grace's name: he petitioned the colony's governor to convene his council in Williamsburg in order to discuss alleged criminal offenses of witchcraft committed by Grace Sherwood.[65]

In Hill's claim, he stated that the community's long-held suspicion that Grace was a witch was valid and that, as a result, his wife's violent actions towards her were completely justified. The attorney general rejected the petition because it was too generalized and said that only a county court (not an individual colonist) could initiate proceedings at this higher judicial level. Instead, the attorney general instructed the Princess Anne County justices to "make a further examination of the matters of fact…& if they thought there was sufficient cause" to send Grace to "Genll prison of this Colony in Williamsburg to await appearance at General Court."[66] She was taken into the sheriff's custody and escorted to the local jailhouse.

The sheriff was ordered to search the Sherwood property for affects that would suggest witchcraft, as per Michael Dalton's instruction. Meanwhile, a female jury, led by forewoman Elizabeth Barnes, was convened for the

purposes of inspecting Grace's body for physical deviations indicating witchcraft. This Elizabeth Barnes was almost certainly the same woman whom the Sherwoods had sued some years earlier.[67] In her report back to the court, Barnes describes Grace's body as having "spotts" and "titts"[68] that were in keeping with "witch's marks."

As per the legal guidance the justices had at their disposal, the colony's growing skepticism regarding witchcraft since the pall that had fallen over Salem fourteen years prior and concerns over Barnes's prejudice against Grace, there wasn't enough evidence to adequately and legally determine if Grace was guilty of criminal witchcraft. Another less-biased female jury was convened to perform a second physical examination of Grace's body. This time, the jury recused themselves, either out of sympathy for or fear of Grace.

Despite the aggressive investigation, justices could not adequately render a decision as to whether Grace was legally engaged in witchcraft. They wrote that they "have all means possible tried either to acquit her or to give more strength to the suspicion that she might be Dealt with as Deserved."[69] The court turned to the Hopkins pamphlet for guidance on how to move forward to determine Grace's guilt. They released their decision on how they would pursue as follows:

Whereas for this several courts ye business between Luke Hill and Grace Sherwood on suspicion of Witchcraft have been for several things omitted particularly for wanted of a Jury to search her ye court being doubtful that they should not get one to search her & ye court give more strength to ye suspicion yt she might be dealt with as deserved therefore it was ordered ys day by her own consent to be tried in ye water by ducking. But ye weather being soe bad, and rainey yt possibly it might endanger her health. It is therefore ordr yt ye Sheriff be requested to secure ye body of ye said Grace till ye time be forthcoming for her to be dealt with.[70]

Despite guidance from the pamphlet, the jury never had any intention of allowing Grace to drown. A point of consecrated water in the north Lynnhaven River behind John Harper's plantation was chosen. Once in the water, Grace would be submerged no deeper than "a man's depth" and never allowed to stay underwater long enough to drown. The original date for her trial by water was set for July 5, 1706 but was delayed due to poor weather. The magistrates wanted to ensure preservation of Grace's health and wellness. A final date for her ducking was set for July 10, 1706.

That morning, a jury of 5 "antient women" gathered to perform a third examination of Grace's body. They reported that Grace was "not like them nor noe other woman" with "two things like titts on her private parts of a Black coller being blacker than the rest of her body."[71] The normally outspoken Grace refused to say anything on her own behalf.

At ten o'clock, she was taken in a small boat to the chosen spot in the river. She was cross bound, left thumb to right toe and the like for her other hand and foot. Once her ties were double-checked, she was tossed over the side into the water. Within moments, witnesses gasped as they watched Grace swim to the surface, completely free from her bindings. This was confirmation to them that Grace was indeed a witch. They could not comprehend that she was a skilled swimmer who wanted to save her own life (or perhaps it was Grace's way of thumbing her nose at the entire spectacle).[72]

Grace was dried and taken to the county jail. After a few days' time, she was transported to Williamsburg to stand criminal trial. While all records from the Williamsburg trial have been lost or destroyed, it can be surmised that the Governor's Council found her guilty of the charges. She spent seven years imprisoned before her recorded release in 1714.

After being released from prison, Grace petitioned Governor Alexander Spotswood to receive the official, legal title for the property she had called

Reconstruction of the public gaol in Colonial Williamsburg. *Nancy E. Sheppard.*

home for her entire life. In exchange for two pounds of tobacco per acre, the governor granted Grace the land patent, as well as "to her heirs & assigns forever."[73] This land patent formally and legally recognized Grace Sherwood as a landowning member of the community. As of 1731, she remained one of only five female landowners in Virginia and the only one designated a widow.

The rest of Grace's life was quiet. She happily remained and worked her land, far from the community's judgmental eyes. When she died in 1740, she left her land and the bulk of her estate to her youngest son, John (more than likely because John already lived there and helped maintain the property), and to her two elder sons, James and Richard, five shillings apiece. Grace's grave has never been found, and its location is left to the stuff of urban legends.

ON JULY 10, 2006, on what was the 300th anniversary of Grace's ducking, Governor Timothy Kaine (D-VA) formally exonerated Grace Sherwood of the charge of witchcraft, legally restoring her good name. The following year, Richard Cunningham's statue of Grace was dedicated at the corners of Witchduck Road and Independence Boulevard, where she can be seen carrying her basket and tending to her animals. The place where she was ducked is now known as Witchduck Point, and the surrounding neighborhoods are nicknamed Gracetown.

THE DUBBED "WITCH OF PUNGO" was not a witch, nor did she deserve the harsh treatment she received from her contemporaries. Grace Sherwood was a strong-willed woman, unable to accept the constraints that the expectations of being a female of her parish shackled upon her. She was a victim of societal paranoias, the power of idle gossip and the necessity of a clean reputation. Grace Sherwood was an early American icon of feminism and will always remain the much beloved heroine of Virginia Beach.

BLACKBEARD AND HIS MEN

Hampton and Williamsburg, 1718

For T.J.

As previous chapters have depicted, Virginia's colonial world was one full of turbulence, turmoil, defiance, resistance and a constant struggle between moving forward with change and staying put in a nearly untenable status quo. This chapter rejoins Hampton Roads' Peninsula when Virginia was still a colony, now just over a century old. It was still struggling to forge its identity and status in the not so New World. The capital moved from Jamestown to the more central, and farther inland, Williamsburg. In no way did it physically resemble the rudimentary wood and clay buildings found in early seventeenth-century settlements. This capital stood with more opulence and civility than its earlier frontier thriftiness. The population increased exponentially, and despite considering themselves English in every way, a growing number of colonists had never spent a moment of their lives in England.

The prominence of Virginia's capital was partly in thanks to the funding of piratical activities during the Golden Age of Piracy from 1680 to 1725.[74] The earliest documented piratical interaction with Williamsburg occurred in 1693,[75] when pirates in the James River were captured and their plunder taken. The pillaged goods were used towards the founding of the College of William and Mary.[76] While some colonists appreciated the pirates' trade because of the discounted prices they paid for stolen goods, many merchants, plantation owners and shipping companies resented them and the frequency of their activities.

In 1718, Governor Alexander Spotswood, who had granted Grace Sherwood's petition for the title to her land four years prior, remained in office. He was vastly unpopular, especially among the powerful landed gentry. That May, the eight members of the Governor's Council declined his invitation to attend the annual celebration of the King's birthday at the Governor's Mansion. Instead, they threw their own party inside the chambers of the House of Burgesses. The council invited the city's residents to join in on the festivities, complete with bonfires and freely flowing spirits.[77] This passive omission of the council's antipathy towards Spotswood spoke volumes, and he knew that he needed to launch some sort of large undertaking in order to win back their confidence.

Understanding the threat that pirates presented to Virginians who had land and money, he made a bold declaration to not only bring an end to Virginia's piracy problem but also to go after the most loathsome pirate of all—Blackbeard. To the House of Burgesses, he decreed, "[S]peedy and Effectual measures for breaking up that Knott of Robbers."[78]

But just who was this Blackbeard?

Born sometime around 1680 in what is assumed to be Bristol, England, Edward Teach (also known by the surnames "Drummond," "Thach" and "Thatch") was known in the American colonies as the most notorious of all pirates. Teach started his maritime career serving as a privateer in Queen Anne's Navy during the War of Spanish Succession[79] but later found his calling while serving under famed pirate Captain Benjamin Hornigold. When he joined the crew sometime before or during 1716, Teach became his captain's most trusted right-hand man. In November 1717, Hornigold successfully captured a French slave vessel and turned it over to Teach, who renamed the vessel *Queen Anne's Revenge*.[80]

It was around this same time that Teach adopted the persona that gave him his historical pseudonym, "Blackbeard." The name was derived from the pirate's long, scraggly beard, which he carefully platted with red ribbons. He wore a long, crimson coat, brandishing swords on each hip. He was known to have also filled his pockets with various pistols and knives. To add to his already terrifying appearance, he tied fuses or hemp to the edges of his beard and beneath his captain's cap. Before going into battle, he would light the fuses on fire. When his enemies laid eyes upon the smoke billowing around Blackbeard's face, they were instantly terrified of the piratical madman.[81]

It was more than his appearance that distinguished Blackbeard from his counterparts. He earned his reputation through his ruthless plunders, daring

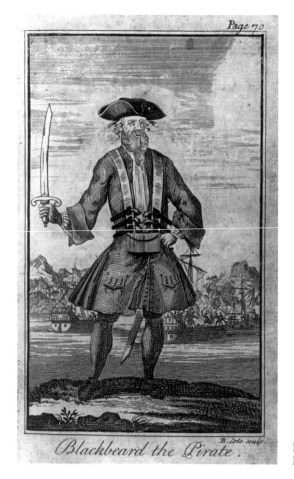

Print from a 1725 engraving of Blackbeard. *Library of Congress.*

blockades of port cities and brazen attacks on other vessels. He amassed a fleet of several ships, three hundred crewmen and approximately forty ship-based guns.[82] They sailed up and down the East Coast, terrorizing ships and cities along the way. His reputation preceded him wherever he went, and Blackbeard positioned himself as the American colonies' most wanted criminal.

In the spring of 1718, he led his fleet to Charleston, South Carolina, where the ships staged a weeklong blockade, demanding provisions, money, supplies and food until Blackbeard was satisfied.[83] However, his exploitation of the city wasn't as successful as he hoped. A few of his sailors were captured and later hanged in the city for their acts. The executed pirates weren't buried in consecrated ground and instead were thrown face down into their graves.[84]

Realizing how easily his safety could be compromised, Blackbeard sailed to North Carolina. He sought a pardon and asylum from the colony's governor, Charles Eden. The governor agreed under the condition that the pirate no longer pursue any illegal activities. Edward Teach readily agreed and left his piratical ways behind him. He married a sixteen-year-old girl (rumored to be his fourteenth wife) and began to settle down in the small town of Bath, North Carolina.[85] This should have been the end of his story. But like many career seafarers, it didn't take long before the water called him back.

In November 1718, Governor Spotswood personally funded two fast sloops to pursue and take down Blackbeard and his fleet. He wasn't without his ulterior motives. Spotswood wanted to find some way to prove that his North Carolina counterpart was not only sympathetic to but also in cahoots with Blackbeard. Proof of governmental corruption in the neighboring colony could potentially change his unlikable reputation and earn back the trust of both Virginians and his superiors in England.

On November 17, Spotswood's ships set sail from Kecoughtan (in modern-day Hampton/Newport News), en route to Blackbeard's base of operations on Ocracoke Island in the Outer Banks of North Carolina. During the voyage, one of the ships was rendered disabled, thus sending a young, zealous Lieutenant Richard Maynard and his crew on board the ship *Ranger* alone in pursuit.

Sailing into Ocracoke Inlet on November 21, Maynard made the assumption that Blackbeard's ship, *Adventure*, substantially outgunned *Ranger*. He knew the necessity of relying on strategy and tactics over brawn in order to vanquish not only the pirate but his entire fleet.

At daybreak, Maynard ran up the Union Jack on *Ranger*'s mast. In speedy response, *Adventure* showed Blackbeard's horned skeleton piercing a red heart flag.[86] Thus began the Battle of Ocracoke Inlet.[87]

Maynard ordered his crew to jettison most of the ship's ballast. A brief sea battle ensued, but Maynard's presumption that he was outgunned proved accurate. He ordered his crew to hide silently below deck in order to lure Blackbeard off *Adventure* and onboard *Ranger*.[88] From across the water, Blackbeard saw nothing but stillness on board his enemy's ship. He assumed they had killed everyone on board and ordered his men to lay claim to *Ranger*. When they boarded the deck of the ship, Blackbeard instinctively knew that something was off. Nothing about this resembled the typical sea battles he was accustomed to. There weren't any bodies, blood or carnage on deck. He turned to his trusted protégé, a former slave

named Caesar, and told him that if something went wrong, it was up to him to destroy *Adventure* instead of letting it fall into enemy hands.[89]

An eerie calm briefly befell *Ranger*. Out of nowhere, Maynard and his crew jumped out from below deck and attacked. The battle was gory, later described by a witness as though the water surrounding *Ranger* was "tinctur'd with Blood."[90] Body after body fell, and the two ships' captains came face to face in an epic showdown. Maynard didn't flinch at the smoke surrounding Blackbeard's face or the weapons his nemesis flaunted. The two fought with great intensity and intent, but Blackbeard proved that he was the mightier of the captains. Just as the pirate readied to kill Maynard, one of *Ranger*'s crewmen leapt behind him and slit his throat. The pirate staggered but refused to give up the fight. He pulled a pistol from his pocket as blood poured from his throat. As he cocked back the hammer of his pistol, Blackbeard collapsed onto *Ranger*'s deck—a death perfectly suited for just such a man. A report regarding his death read, "Here was an end to that courageous brute, who might have passed in the world for a hero had he been employed in a good cause."[91]

Edward Teach's corpse lay on *Ranger*'s deck, riddled with five bullets and twenty stab wounds.[92] Only nine of his men survived the brutal ambush. Caesar attempted to make his escape to destroy *Adventure* but was stopped by two of his frightened shipmates. Maynard ordered the men taken into custody and made them watch as he decapitated their dead captain. His headless hulk was unceremoniously thrown into the inlet, and his bloody, black-haired head was tied to the bowsprit of the ship. *Ranger* left the inlet and was headed towards Bath in search of more members of Blackbeard's crew, conspirators and any of the pirate's rumored treasure.

Without receiving news regarding the battle in Ocracoke Inlet, Governor Spotswood passed the Act to Encourage the Apprehending and Destroying of Pyrates on November 24, 1718. With it, he offered a £100 reward (the equivalent of approximately £20,000 today) for the capture of Blackbeard, alive or dead.[93] With physical proof of his death hanging from *Ranger*'s bowsprit, Maynard would certainly be eligible to collect the prize.

In Bath, his crew searched the barn of Tobias Knight, secretary of North Carolina, collector of customs and the newly appointed chief justice of the colony. Inside, they found casks of cocoa, loaf sugar and sweetmeats, all tied to French trade vessels that Blackbeard recently plundered.[94] Despite having orders to the contrary, Maynard shared a portion of the riches with his crew as a token of thanks for their heroic deeds during battle. He captured six additional pirates as well as evidence implicating Knight in conspiracy.

Reconstruction of the public gaol in Colonial Williamsburg. *Nancy E. Sheppard.*

On January 3, 1719, Maynard and his sailors returned to Hampton and were greeted with great pomp and circumstance. Cheers rose from shore when Virginians saw Blackbeard's decaying head hanging from the ship's bowsprit. Maynard was celebrated a hero for leading the crew that took down the legendary pirate. On January 28, 1719, he took his prisoners to Williamsburg.[95] When they were taken into custody at Williamsburg's public gaol (or jail), shackles were placed around their ankles and wrists before they were thrown into a large, cold cell to await trial.

While Williamsburg's public gaol was better appointed than most other colonial gaols because of certain provisions including privies, the cell was still cold, cramped and only had straw on the floor for the prisoners to sleep on. Their diet consisted of "salt beef damaged, and Indian meal." If the prisoners were ill (usually from gastrointestinal distress), they were provided with a "physick," or a medicine that would force their bodies to purge.[96]

The trial of Blackbeard's men was scheduled for March 12, 1719, before the Court of Vice-Admiralty. Early eighteenth-century maritime law did not afford defendants the right to a trial by jury. This worked to Spotswood's advantage because if they were allowed a jury, they may have been shown mercy because of the public's mixed emotions towards their dubious dealings, thus possibly thwarting the governor's ultimate agenda.

Before the trial commenced, Spotswood wrote to the Governor's Council regarding the African and former slave crewmen captured and asked "whether anything in the circumstances of these negroes to exempt them from undergoing the same Tryal as other pirates."[97] It was decided that, unless there were extenuating circumstances that deemed otherwise necessary, they would endure the same trial and subsequent punishments as the rest of the prisoners.

On March 12, 1719, fifteen pirate prisoners—including Caesar, Israel "Basilica" Hands and Samuel Odell—crowded into the first-floor general courtroom in Williamsburg's Capitol. Israel Hands testified along with four other African crewmen regarding acts of piracy,[98] perhaps hoping for some

leniency from the court. The unfortunate truth is that future generations would never be able to read the actual transcripts because they were lost or destroyed at some point over the years. However, the verdict was never lost to oral tradition: fourteen of the fifteen men tried were found guilty of piracy and sentenced to hang. No mercy was spared for any of their lives, regardless of their testimony.

The only prisoner acquitted of any wrongdoing was Samuel Odell. He was able to definitively prove beyond a doubt that he was not part of Blackbeard's crew and hadn't participated in any of the illegal acts. The court determined that Odell was more of a victim of circumstance, having come on board *Adventure* the night before the Battle of Ocracoke Inlet for an evening of drinking and merriment. During the battle, he was forced to defend himself as a matter of necessity for his own survival rather than a willing participant. He sustained grievous injuries during battle, and the court deemed that and his time in the gaol were punishment enough for any possible wrongdoing.

The day before the hanging was set to take place, Israel Hands received a pardon from the Crown, stating, "Proclamation for prolonging the time of His majesty's pardon to such of the Pirates as should surrender by a limited time therein expressed." Hands was released with a warning never to engage with nefarious figures or in any illegal activities again. The other prisoners received no such pardon.[99]

The remaining men were taken by cart to Gallows Road (now Capitol Landing Road) and saw the newly constructed gallows, which was shaped like a triangle, allowing for several prisoners to be hanged at the same time.[100]

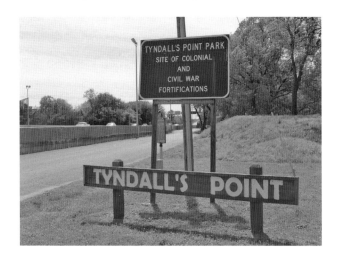

Right: Tyndall's Point in Gloucester. *Nancy E. Sheppard.*

Opposite: Blackbeard's Point Marina in Hampton. *Nancy E. Sheppard.*

Throngs of spectators arrived to watch the macabre spectacle, some even wagering on the condemned men's fates. The convicted pirates were allowed to be attended to by a minister before chains were wrapped around their bodies. Then, they were ordered to stand in the carts and asked if they had any last words. What those words may have been are also lost to history. Heavy nooses were then placed snugly around their necks and their chains double-checked. When ordered, the carts were pulled out from under the prisoners and their bodies dropped, snapping their necks. The unfortunate, grisly deed was done.

Once there were no longer signs of life, the bodies were cut from the gallows, and four were selected for public display. Upon Spotswood's orders, two bodies were chained at Tyndall's Point in Gloucester along the York River and the other two hung in Urbanna along the Rappahannock River.[101] This was customary in England and the American colonies as a warning to pirates who dared to pillage the region.

After the grotesque display was erected, Blackbeard's mangy, decaying head was removed from *Ranger*'s bowsprit and placed on a pole along the Hampton River near its junction with the James River, at what is now known as Blackbeard's Point.

The executions did little to bolster enthusiasm for Governor Spotswood. Many felt that the punishment was far too steep for the pirates' crimes,

and the loss of inexpensive goods in the marketplace was deeply felt by common colonists. The trial and executions were an expensive (and perhaps unnecessary) undertaking, with the sum being paid by the King's revenue of two shillings per hogshead (or large cask used for the transportation) of tobacco. The remainder was paid for from the sale of loot seized from Blackbeard's ships. To his superiors in England, Spotswood wrote, "Sundry effects piratically taken by one Thack [note: Teach] out of which is to be deducted the charges of recovering the said Effects out of the hands of the Pyrates, the transportation from Carolina the Storage and Expense of the Sale."[102]

Tobias Knight was sent to trial in North Carolina on charges of corruption and working in collusion with Blackbeard, and portions of the testimonies given at the pirates' trial in Williamsburg were sent to Governor Eden. Spotswood secretly hoped that this would intimidate and discredit his North Carolina counterpart, but Knight was acquitted of all charges.[103] There has never been any substantial proof found to support claims of any improper friendship or involvement between Governor Eden, Tobias Knight and Edward Teach. The only documents that remain are letters written by Spotswood, which lack accreditation due to his inclination to embellish in order to garner more favor from England.[104] Tobias Knight passed away not terribly long after his trial from an unknown chronic illness.[105]

Eventually, Blackbeard's fleshless skull was removed from public view, and urban legend says that it was turned into a silver-plated punchbowl. No such artifact has ever been found.

IT TOOK FOUR YEARS to pay the bounty that Spotswood promised for Blackbeard's death, which was paid to the men who recruited Lieutenant Maynard, Captains Brand and Gordon. Maynard protested that, since he and his men were the ones who actually killed Blackbeard, the entirety should be divided among those who served on board *Ranger*. His petition made its way to England, where it was determined that the bounty payment would stay as is because Maynard disregarded orders when he divided the seized plunders among his crew and himself. Each member of the sloops sent by Spotswood was paid a portion of the reward.[106] In 1721, Maynard resigned his commission and returned to his family in Kent, England. Like the man whose life he helped cut down, the sea called him back, and he returned to the Royal Navy before eventually retiring with the title of "Master and Commander." In 1751, he quietly died in Kent at the age of sixty-seven.[107]

The whereabouts of the executed pirates' bodies remains another historical mystery. In the mid-1980s, archaeologists were excavating along the shoreline in downtown Hampton near where the Crowne Plaza Hotel currently stands. Between the high- and low-water marks, they found the partial skeleton of a man who was unceremoniously buried facedown. After a battery of tests were performed, it was determined that the skeleton was from the period of the pirates' trial.[108] Could he have been one of the executed prisoners?

WITHOUT IRREFUTABLE DOCUMENTS AND physical evidence, much of this story has become folklore and tall tales. But ask any Ocracoker and they will tell you their local legend: if you look closely at the inlet on a clear night, the decapitated ghost of Edward Teach can be seen swimming in circles, eternally in search of his lost head.

THE BURNING OF HAMPTON

Hampton, 1861

After the time of Edward Teach, Virginia continued as a key player in a radical transformation. America went from English colonies to an infantile sovereign nation with varying identities in each of the different states, dependent on the socioeconomic conditions of each region. Virginia stood right on the fault line between agrarianism versus industrialism as tensions between the two sides of the nation burned a short fuse towards an explosive mid-nineteenth-century powder keg, leading the nation into a civil war. While the war had many causes, the freedom and rights of *all* Americans remained at its roots.

THE STRUGGLE FOR RACIAL freedom and equality is one of the intricate yet delicate threads that holds the tapestry of Hampton Roads' history together. This region has long stood precariously between prejudice and freedom, with evidence of the struggle in every corner of each city.

At the dawn of the Civil War, Hampton was known as a charming, picturesque port city. It was the seat of Elizabeth City County and was considered one of the most important trade ports in the United States. The hustle and bustle within this merchant city was lively and attracted people from all over the country seeking profits.

Brick-chimneyed homes lined the city's brick-paved and granite-curbed streets. On Sundays, the city's white residents met in the center of town and worshiped together at St. John's Church. Visitors and locals alike

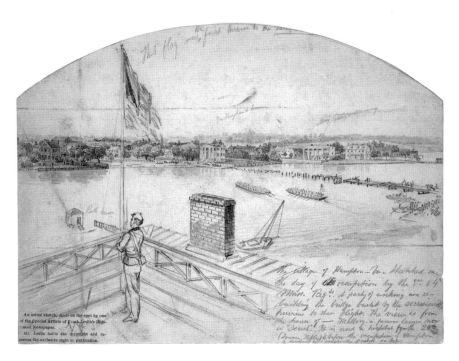

Francis H. Schell's drawing of the occupation of Hampton by the Third and Fourth Massachusetts. *New York Public Library.*

flocked to the nationally renowned beachside resort at the Hygeia Hotel for rest and relaxation.

Despite its visual opulence, Hampton was reliant on nearby Fortress Monroe at Old Point Comfort for military protection and financially dependent on the city's trade port and the prosperity of nearby slaveholding plantations. Hampton grew to become a Southern American gem because of the cruelty of chattel slavery.

When the war's initial fighting occurred in April 1861, Federal troops occupied Hampton under governmental concern that Virginia would follow suit with other Southern states and leave the Union. Their fears were realized the following month when the Commonwealth passed a successful vote for secession.[109] With the powers that be in the Federal government recognizing the strategic position that Fortress Monroe held, ten thousand Federal troops came ashore at Old Point Comfort within the first one hundred days of war.[110]

Major General Benjamin F. Butler, a Massachusetts lawyer by trade and recognized military strategist, was stationed as the fort's commanding

officer. He ordered a blockade at the mouth of the river that fed into the Chesapeake Bay,[111] essentially strangling the region by way of the sea. Butler was an unlikable, abrasive man, but his role in securing freedom for America's enslaved people was nothing short of necessary and heroic.

Meanwhile, Confederate troops on the Peninsula were under the direction of Colonel John Bankhead Magruder. He understood that his troops were vastly outmanned and outgunned by the Union. In an attempt to protect Southerners from potential attack, Magruder ordered his men to advise those living in and around Hampton to pack their movable property and evacuate the city. Residents prepared for a mass exodus and made arrangements to leave with their most valuable property—their slaves.

Major General Benjamin F. Butler. *Library of Congress.*

Many enslaved people were not willing to leave, knowing that Butler's help was so close. On May 24, 1861, Shepard Mallory, Frank Baker and James Townshend, all enslaved by Confederate Colonel Charles Mallory, escaped to Fortress Monroe. When they arrived at the palisades, the three men sought refuge. Butler welcomed them inside, promised his protection and told them that they would not be returned to the oppressive life from which they had bravely fled.

The next morning, Major John Cary of the Virginia Artillery arrived at the fort on behalf of Colonel Mallory. Citing the Fugitive Slave Act of 1850 (which allowed for captured runaway slaves to be returned to their owners), he demanded that Butler hand over the three "fugitive slaves." However, Butler held true to his word and refused to return them. He stated that since Virginia had seceded from the Union, its residents were no longer afforded the rights and protections of Federal law, including the Fugitive Slave Act of 1850. Furthermore, because these men were considered "property" by those now declared his army's enemy, they were considered "contraband of war." Any enslaved person could be taken at will by his army, thus granting freedom and sanctuary to all who came to his gates.[112] This was considered a

Period depiction of slaves escaping to Fortress Monroe. *Library of Congress.*

direct act of war against the Confederacy, and news of Butler's declaration reverberated throughout the world. Local plantation owners panicked, knowing that their slaves, who were financially irreplaceable if lost, had the ability to escape and never be returned to them.

By late July, approximately one thousand formerly enslaved people had found protection within the walls and in the immediate vicinity of Fortress Monroe. By the declaration made by one white Massachusetts lawyer, freedom was within reach for enslaved people in the South for the first time. For Butler, he faced the bigger problem of how to house and care for all the refugees arriving each day.

He wrote to Secretary of War Simon Cameron and asked for instruction. Cameron advised him to allow the contraband to occupy the largely abandoned houses in Hampton while remaining under Butler's protection from Rebel retaliation. The Union still held the military advantage in the region, while simultaneously blocking the Peninsula Confederate forces' corridor to their capital city in Richmond.

The result of the First Battle of Bull Run on July 21, 1861, was a major blow to the overly confident Union forces. Knowing the Confederacy's proximity to Washington, D.C., it was necessary to move troops in order to guard the nation's capital. More than four thousand Union troops were pulled from Hampton to help protect Washington, D.C., leaving the city largely unguarded. Magruder saw this as an opportunity to attack Federal forces in order to gain control of the corridor to Richmond and reclaim Hampton for the Confederacy.

Like many military strategists at the time, Magruder gathered intelligence by simply reading his enemy's newspapers. It was in an edition of the *New York Tribune* that he learned about Butler's continued intentions not only to settle contraband in the largely deserted Hampton but also to use the empty structures as fall and winter barracks for Federal troops. Outraged,

Magruder was convinced that he had to act in order to prevent the city from falling completely under Union control. He ordered Rebel detachments in Yorktown and Williamsburg[113] to join him in an ultimate act of rebellion: the complete destruction of Hampton.

On the night of August 6, 1861, Magruder's five hundred troops spent the night in Big Bethel, which bordered the York and Elizabeth City County lines. One member of the Confederate forces named E. Mahew silently slipped from Big Bethel and made his way to Fortress Monroe. When he arrived the next day, Mahew begged for Butler's sanctuary in exchange for information. He claimed that though he came from Georgia, he was actually a native of Maine.[114] Butler acquiesced to Mahew's request and patiently listened as he relayed Magruder's plan to decimate Hampton. By then, it was already too late for Butler to do anything to protect Hampton from Magruder.

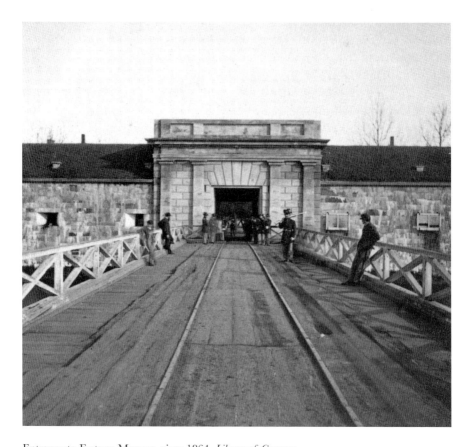

Entrance to Fortress Monroe, circa 1864. *Library of Congress.*

At 11:30 p.m., Magruder's forces marched into downtown Hampton. The Rebels called out to the handful of people who remained in the city, warning them to leave immediately or face possible injury. Fortress Monroe's assistant surgeon, Dr. Smith, was in the city, tending to an elderly couple. After hearing the warning, Dr. Smith fled on foot with the couple in tow.

Magruder's men met at the city center by the west wall of St. John's Church and split into quadrants. They knocked on the doors of each building before thrusting a burning torch through the windows. People fled the buildings, some frightened and injured, while others grabbed torches to aid in the confusing spectacle.[115]

Mr. Scofield, a Connecticut native and resident of Hampton since 1856, heard a loud ruckus in the street and climbed out of his bed on the second floor of Mrs. Kenner's boardinghouse. While he was dressing, flames shot up into his room. He ran through the inferno and burst through the building's front door. After spotting soldiers carrying torches, a frightened Scofield ran the other way. He heard pistol fire from behind him before a bullet pierced into his body. He continued running and didn't stop until he reached Fortress Monroe.[116]

Across the Hampton River, Union troops watched in horror as the night sky turned vibrant orange from the flames in the city. A strong southerly wind and a recent dry spell made the fire spread far more rapidly than anyone could have anticipated. Private William H. Osborne of the Twenty-Ninth Massachusetts Volunteer Infantry wrote, "Suddenly, the flaming torches were seen dancing about wildly in all directions, like so many will-o'-the-wisps.…The houses were entered and fired, and soon the whole town was enveloped in flame casting a bright light over the bay."[117]

An Associated Press correspondent witnessing the madness described, "The glare of the conflagration was so brilliant that I was enabled to write by it. A more sublime and awful spectacle has never yet been witnessed."[118]

From miles away, people woke from their slumber to watch in horror as the once great port fell into ruins. In the city, brick buildings collapsed into their basements; the heat creating a burn layer of molten glass between the crumbled walls and chimneys.[119]

The fire continued to burn well into the early hours of the next morning. By dawn, the blaze had dulled to a quiet wisp of smoke as the Confederate troops evacuated. Beleaguered former residents and Union troops arrived a little while later, and what they found was virtually unrecognizable. Among a forest of brick chimneys was nothing but smoke and ash. St. John's Church was reduced to a shell, and the scorched brick streets and granite curbs were

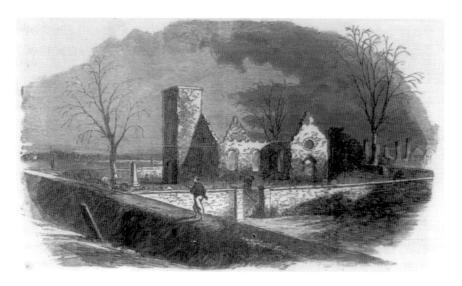

Historic St. John's Church after the fire. *Library of Congress.*

covered in a thick layer of soot and debris. Out of the five hundred structures that stood the day before, only a handful survived. These buildings included a couple of houses, St. John's parsonage, a store and a warehouse.[120] It is unknown how many people were injured or died in the fire, but reports ranged from a couple of enslaved men to around sixty people.

Southern newspapers initially blamed Butler for the city's destruction. They embellished upon the Southern stereotype of Northerners being uncivilized heathens who were without any understanding of honorable warfare. South Carolina–based newspaper the *Charleston Mercury* fictitiously described the scene allegedly carried out by Butler's men: "Some of the foulest discretions of these houses and homes of our Virginia people, including using the parlors of some of the houses as latrines, as well as writing obscenities on the walls."[121]

Other newspapers described soldiers destroying fences, trampling flower beds and disrespecting other well-appointed parts of the genteel homes.[122] It was this false reporting of alleged defacement to "civility" that was so ingrained in Southern culture that riled up the masses. Their counterparts in the North countered with the obvious: this was not the doing of Butler or the Union army.

Days later, the truth was finally revealed that this was a Magruder-planned and led attack on Hampton. His actions were deemed justifiable by the South in that sacrificing the city was a necessity to the Confederacy's

military strategy. Montgomery, Alabama's local newspaper, the *Weekly Advertiser*, published: "As painful as it must be to destroy this ancient and venerable town, we must confess that it is far better than to have it standing and occupied by the worse than barbarian troops of the enemy."[123]

While the Southern newspapers touted Magruder as a hero, Northern papers expressed confusion over why Magruder needed to burn down a city of no true strategic or military importance. The burning of Hampton was used as a prime example of the Northern perception of Southerners as irrational beings who were inherently violent.

In the aftermath of the fire, Major General Butler had the "last laugh." He followed through on his orders and aided Fortress Monroe's contraband to build and settle in Hampton, creating the Grand Contraband Camp. Undamaged bricks and other construction material from the city's ruins were used to build a town later described by author John Trowbridge as "thrifty." Refuse and other unusable material were thrown into the former basements of the hollowed-out structures. Among a forest of burnt brick chimneys rose one of the first self-contained African American villages in the country.

At the urging of Major General Butler, freedwoman Mary Peake taught her first class underneath an old oak tree on September 17, 1861. This

Emancipation Oak in Hampton. *Nancy E. Sheppard.*

was illegal in Virginia since a law had been passed that forbade persons who were enslaved, freed African Americans and those of mixed race from obtaining any sort of education. It was under this same tree that the first official Southern reading of the Emancipation Proclamation took place in 1863. This old oak tree has become a beloved icon in Hampton, now known as the Emancipation Oak.

Butler continued to support Mary in her endeavors to educate the children of the newly dubbed "Slabtown." He diverted government funding in order to open an institution, originally named Butler's School for Negro Children. The school's mission was to teach its students reading, arithmetic, grammar, writing, geography and basic housekeeping skills. Today, Mary's tutorage and Butler's school are credited as the foundations for the highly regarded higher-education institution Hampton University.

Despite Magruder's attempts to thwart any contraband and enemy soldiers from occupying Hampton, through his own devices, he helped make just that a reality. From the ashes and flames rose a thriving city. For the first time, this was a place where so many once enslaved on the city's periphery were finally free.

THE NORFOLK RACE RIOT

Norfolk, 1866

The immediate aftermath of the Civil War left a broken country struggling to find a unified identity within the problems that led to the nation's schism in 1861. For African Americans, while decades of unfathomable oppression had come to an end, their struggle for legal and cultural equality was just beginning. For the Confederate supporters still living in the formerly seceded states, their defeat was a humiliating blow. With their economy devastated, an untenable rage was building in city streets, with a focal point of their rage directed towards those they had formerly enslaved.

Located on the northernmost tip of the south side of Hampton Roads and across the river from Fortress Monroe sits the port city of Norfolk. Following the war, the composition of its population changed. The African American population rose to approximately 45 percent immediately following the war, composed in large part of former slaves and soldiers.[124] With a meek Mayor Thomas Tabb at the city's helm, Norfolk was a haven for lawlessness, with soldier versus soldier, black versus white, liberator versus former oppressor and neighbor versus neighbor, still warring with one another. A plain-clothed civil police force did little to discourage violence against or to protect the city's black population. A March 1866 edition of the *Petersburgh Journal* best summed up the city by stating, "Norfolk is a strange place."[125]

Recognizing a need to protect themselves, former African American soldiers took advantage of their legal right to purchase the service weapons they were issued during the war. Members of the community formed organizations to self-police, while also advocating for equality. Among these

A drawing of Norfolk, circa 1850–60. *Library of Congress.*

organizations was the Colored Monitor Union Club. Led by former slave turned dentist Dr. Thomas Bayne, its purpose was to stand up to Mayor Tabb's ineffective leadership, change public perception of African Americans and peacefully fight for the right to vote.[126]

While the newly freed African Americans were rightfully empowered in ways that they hadn't been before, the white population continued growing in its resentment towards its new neighbors. Southern, white-controlled newspapers never shied away from using derogatory language to refer to African Americans. They published slanderous propaganda, painting a fictitious image of African Americans as wild, heathenistic animals. In Norfolk, former members of the Confederate army remained organized, publicly for social reasons, but met in private to discuss farfetched plans of insurrection against the government they had rejected nearly half a decade prior.[127]

On December 18, 1865, the Thirteenth Amendment was ratified, which formally abolished slavery once and for all in the entirety of the United States. The next natural progression was for some sort of legal mandate that granted blacks equal rights and protections under federal law, including the right to vote. Many radical Republicans felt that the only way to create a multicultural South was to force federal governmental oversight and protections, superseding individual state governments and decrees. Senate Judiciary Committee chairman Lyman Trumbull of Illinois was the first to introduce the Civil Rights Bill of 1866. The bill provided African Americans equal liberties, rights and protections under federal law, thus disbanding all state laws considered prejudicial therein. Once

the bill hit President Andrew Johnson's desk, he vetoed it. He claimed his justification to be that he felt that the intense level of federal governmental intervention required by the bill was unnecessary and, perhaps, dangerous at this precarious time. In his memo, President Johnson wrote that this was "another step, or rather a stride, towards centralization and the concentration of all legislative power in the national government."[128] On April 9, 1866, the House of Representatives overturned Johnson's veto, and the bill was set to become law.

When learning of the news, Norfolk's African American community rejoiced. In celebration, plans were made to hold a public procession through the city's streets, followed by speeches given by community leaders on April 16, 1866. When the white population caught wind of the plan, they set into motion nefarious plots to stop it. With a weak mayor and a largely ineffective police force, the protection of the city's African Americans lay in the hands of their own community and with Captain William Stanhope, the commanding officer of the U.S. Twelfth Artillery, stationed in Norfolk.[129] Stanhope coordinated efforts to provide any military force necessary. He ordered his men to remain armed, at their posts and prepared to fall in at the first sign of trouble.[130]

On the morning of the procession, a crowd of approximately three hundred people gathered from Norfolk, Portsmouth and the surrounding cities. They carried signs with the names of community organizations, including the Monitor Union Society, the Ballot Box for All, Sons of Honor and the Sons of Rising Freedom.[131]

By all accounts, the marchers were peaceful yet resilient while walking through Norfolk's streets. Former soldiers and the local military detachment flanked the stoic marchers in order to protect them as counter-protesters brazenly hurled bottles, rocks and bricks from behind fences and along the sidewalks as they passed by.

City watchman William Moseley stood among the rest of the white counter-protestors. Like many in the city's divided population, he held unjustified resentment towards African Americans. Witnesses reported that Moseley appeared drunk as he yelled egregious language and flung foul gestures towards the procession. The marchers continued to retain their composure in front of his vulgar display.

Another Norfolk resident was former Confederate army private Robert Whitehurst. An altercation with two African American men just days prior to the march left him reeling with unfocused rage. When he learned that the parade was heading in the direction of his family's Nicholson Street home,

A depiction of Market Street in Norfolk. *New York Public Library.*

Robert bolted to his stepmother Charlotte's room and grabbed her revolver. She attempted to stop him, but he shoved her aside.[132] Robert watched patiently until 3:00 p.m., when the parade halted on the field near his home at Nicholson and Upper Union (now Smith) Streets. He watched intensely as the speakers began taking to the platform. Robert sprung from the front door and raced through the crowd.

As he raced through the throngs of people, Robert spotted the men with whom he had quarreled and pulled out the gun. A loud *bang!* cut through the crowd. Everything seemed to pause as an innocent African American bystander fell face-first, dead, into the mud.[133] A cacophony of confusion and fury followed. An angry mob chased Whitehurst as he doubled back towards his house. Meanwhile, William Moseley claimed to have witnessed a pair of African Americans firing blanks at each other. He foolishly jumped into the fight and threatened to disband the incoming mob by force. He pulled a blade from his pocket, slashed it clumsily through the air and stabbed at least one man.[134] A small cluster of the people chasing Whitehurst turned on Moseley to protect their own from his violent, erratic behavior. He was badly beaten by the mob but managed to escape.

While running away, Whitehurst was shot by an unknown assailant before stumbling through the front door of his home. Charlotte pleaded with her stepson to stop the madness. Blood was oozing from his wounds and he was growing weaker by the second. He dismissed his stepmother and reloaded the revolver. But all was for naught as he collapsed to the ground. As he fell, the

revolver discharged, gravely injuring Charlotte.[135] Robert died in Charlotte's arms while she was dying from the injury he accidentally inflicted on her.

Captain Stanhope arrived on scene to unfathomable madness. The peace he witnessed marching through the streets that morning erupted into bedlam. One of his men reported Whitehurst's injury and subsequent death. Stanhope ordered his men to surround the parade grounds and not allow any African Americans to leave. He personally inspected and confiscated all of the marchers' weapons and ammunition.[136]

The violence continued to escalate in Norfolk's bloodstained streets well into the evening. Local authorities proved fearful and useless in any effort to end the violence. Mayor Tabb begged Stanhope for aid in order to restore any sense of civility in the midst of chaos. In turn, Stanhope requested military reinforcement, which arrived by way of Fort Monroe from the Fifth U.S. Artillery and Second U.S. Infantry.[137]

Norfolk resident Jesse King and a man only identified as Benson spent the evening taunting and threatening African Americans. They threatened to bash their heads while King gestured to his personal weapon. Stanhope's forces chased King and Benson through the streets before apprehending them and hauling them off to the federal jail.

Meanwhile, a few men were shot in front of the Atlantic Hotel, and another African American was brutally murdered in front of the city's jail. Approximately one hundred members of the U.S. Fire Company, dressed in the gray uniforms they wore while serving under former General Robert E. Lee, charged Stanhope and his men, engaging in brutal street warfare. At 11:30 p.m., Stanhope received permission to declare martial law in Norfolk as a last-ditch effort to regain control.[138] His superiors also ordered him to turn over King and Benson to civilian authorities to be dealt with. Benson was immediately released because he was not witnessed using a weapon. Soon thereafter, they also released King without any repercussions.[139]

The turbulence continued throughout the night, but gradually, military forces were able to turn the tide and regain control of Norfolk. On Tuesday, a group of white men gathered together and threatened to crush the military while they "exterminated" the city's African Americans.[140] All of this amounted to verbal terrorism and never manifested into the physical violence experienced the day before. Though rumors persisted as more reinforcements arrived from Washington, D.C., none came to fruition. In his reports, Stanhope credits the excessive military presence and martial law as the reasons why he was able to bring the city so quickly back under control while preventing future violent outbreaks.

Unidentified soldier in Norfolk "Light Blues" Virginia Light Artillery Battery uniform. *Library of Congress.*

True to form, southern newspapers did not shy away from using derogatory language, placing the blame entirely on Norfolk's African American population. The papers printed stories stating that the procession's meaning was of "melancholy significance for us."[141] The *Louisville Daily* even printed an article falsely claiming that African Americans did a "dance of death" over Robert Whitehurst's body, all while painting both Whitehurst and William Moseley as tragic figures in the now irrelevant Confederate cause.[142]

On May 2, 1866, a board of inquiries was held behind closed doors at Norfolk's Customs House. This was an attempt to ascertain the antecedents behind the city's violent eruption. The board members heard testimony from sixty-eight witnesses, most of whom made it quite clear that Norfolk was no haven for African Americans and former Unionists. An army surgeon was quoted as saying, "Loyal men could not live here an hour."[143]

After the inquiry board completed its investigation, seven African American men were arraigned for the riot and murder of Robert Whitehurst. It must be noted that no one was ever brought up on charges for crimes perpetrated against the African American community. All but one of the seven men were released due to lack of evidence. Edward Long was sentenced to eighteen months in prison for allegedly carrying out the Whitehurst murder (though the charges were later dropped and he was released).[144]

THE RIOT IN NORFOLK served as the first major explosion of the overwrought racial tensions that existed during the Reconstruction era. It was soon followed by violent eruptions in other southern cities, including New

Orleans, Richmond and Memphis. Newspapers across the South defamed African American organizations, deftly harming the valiant efforts made by the communities and their civic leaders in restructuring their image within American society. Furthermore, it proved that the Civil War hadn't ended when the ink dried in 1865 but instead transformed from legal combat into a societal war that permeated American streets and side parlors. The riot in Norfolk showed the beginning of the long, difficult path that African Americans had in front of them, earmarked by the heroic efforts of so many brave souls who gave so much, even their lives, in the name of what they should have been granted to begin with—freedom and civil rights.

A MURDER AND LYNCHING IN PRINCESS ANNE COUNTY

Princess Anne County (Virginia Beach), 1885

A simple marble headstone in Norfolk's Forest Lawn Cemetery is etched with a rather chilling message:

Medora Alice Powell
Died
November 12, 1885
Aged 10 years 4 months
Murdered on her way to school

This haunting epitaph of a young, innocent child could never sufficiently describe what occurred that morning in 1885, the immediate fallout after her death and the even deeper cultural implications that this girl's death revealed in the pathos of mob mentality superseding rational presets of lawful justice and the acceptance therein.

In 1885, Princess Anne County had barely evolved since the time of Grace Sherwood a century and a half earlier. It was still very rural and agrarian-based. Wealthier families owned large swaths of land and leased out plots to other families, in a sort of modern feudalism. Alice Powell was the youngest of seven children, and her family lived near the Village of Kempsville on a plot of land listed in historical records as either under her family's last name or under the name of "Brooke Farm."[145] Her father, Charley, and one of her older brothers tended to the farm while her mother and sisters kept house. Alice lived a blissful childhood. At only ten years old,

Medora Alice Powell's grave in Norfolk's Forest Lawn Cemetery. *Nancy E. Sheppard.*

she was considered too young to help with the manual labor required to maintain the farm, so she spent her days attending Hickory Bridge schoolhouse. Her walk to school was a beautiful three-mile trek through the rural wilderness of Princess Anne County. When she wasn't in school, she whittled her time away, playing around the farm with her siblings or visiting her older sister, who also lived in the village.

The world that Alice Powell was born into was one that her young mind probably couldn't fully comprehend. The wounds of the Civil War were still incredibly raw, and an inherent racism ran as the deepest vein through the culture. Though hired to work on local farms, African Americans were far from receiving any sense of equality, let alone respect, from their white neighbors. Derogatory phrases continued as common vernacular in speech and publication to reference them and their communities.

But there wasn't any way that the naïve Alice Powell could fully understood the level of hatred that permeated the world around her. She was a young, innocent girl, wide-eyed to the world, with the rest of her life sprawled out in front of her.

On the Powell farm, Charley often hired local African Americans as farmhands. For the most part, his experiences were rather unremarkable. Recently, he had hired a young man named Noah Cherry. The sixteen-year-old lived in the village with his grandmother, Jennie Lindsay.[146] He was a troubled young man from a family with a checkered past. Both his father and grandfather were executed in North Carolina for separate murders that they were convicted of.[147] Noah was known for being hot tempered, irrational and filled with rage due to an upbringing of unfortunate circumstances, fueled by living in a culture that hated him simply because of his skin color. He garnered a reputation in the Kempsville community as "trouble." In early November 1885, Noah engaged in a violent altercation with one of Charley Powell's sons and was fired as a result.

The morning of November 12, 1885 was unremarkable in the Powell household. Charley rose early, and Alice's siblings spread to their various

Kempsville village in Princess Anne County. *Library of Congress.*

corners of the farm. Martha Powell lovingly packed her youngest daughter's lunch basket to take to school with her. Alice carried her geography, reading, writing and spelling schoolbooks in one arm and the basket with the other. She said goodbye to her mother and then skipped out the door, headed towards her school. Nothing was out of place or different from any other morning. She disappeared down Holland Swamp Road while gently singing the tune "Sweet Bye and Bye."[148]

Later in the morning, storm clouds released a torrential downpour over Kempsville. When Alice didn't return home at the usual time, Martha and Charley assumed that she had stopped to visit her older sister and sent one of their sons to retrieve the little girl. When he arrived at his sister's house, Alice was nowhere to be found.[149]

Alice's brother rushed home to tell his parents the first of many horrors that were to come that night. Charley gathered a search party and traced the girl's morning walk along Holland Swamp Road. On the side of the road laid the overturned lunch basket that had been so lovingly packed by Martha Powell that morning. Its remnants were partially eaten and discarded along

the edge of the thicket. When they inspected further, they found a large smear of blood leading into the brush.[150]

The search party slowly entered the woods, screaming Alice's name as loudly as they could. The blood that was smeared on the ground created a path for the searchers to follow in the cold November night. They reluctantly traced the dark red trail that stained the wet grass and plants, hope of finding Alice safe and sound diminishing with every footstep. At 11:00 p.m., Alice's brother let out a gut-wrenching scream. Lying at the end of the gory pathway was the tattered, lifeless body of little Alice Powell. Her cold, tiny body was left facedown in puddles of sludge mixed with her own blood.[151]

The girl's corpse showed telltale signs of the unspeakable hell she endured in the last moments of her life. Her undergarments were ripped, though an examination later determined that she was not sexually violated. Alice was covered in bruises and stab wounds, indicating that she must have tried to fight off her attacker. Worst of all her injuries was a massive gash across her neck that ran from right to left, so deep and wide that a grown man's hand could easily fit inside the little girl's neck. Alice was nearly decapitated in the final moments of her life.[152] It was a horrifying sight that no one could prepare himself for.

A member of the search party left to retrieve the police while others attempted to gently lift Alice from the ground, carefully cradling her head and neck. Just a few feet from where her body lay was her soaking wet, blood-stained geography textbook.[153] All of the rest of her belongings were accounted for, with the exception of three books and a school sponge.

The police arrived within hours of the grisly discovery. They determined that Alice must have been attacked on the side of the road and then dragged facedown to where she was found. The attacker left a sloppy scene behind, which hinted at inexperience or irrational judgement. More telling was the slash to her neck. If the murderer were typically right-handed, the slash would have run from left to right. But this particular gouge ran in the opposite direction, indicating that Alice's murderer was left-handed.

Alice's body was returned home, where she lay in repose as members of the small rural community arrived throughout the night to pay their respects. Neighbors shared in the family's grief. Who so evil and hateful could have done such a horrific thing against an innocent child?

In the morning, Kempsville's Constable Ferrall and Investigator John Herrick followed the direction from where Alice's geography book was found the night before. On the ground, they discovered more blood and followed it through the thicket until they were standing in front of the home

that Noah Cherry shared with his grandmother. Having knowledge of the ill will that lay between Cherry and the Powells, the investigators decided that they needed to question both Noah Cherry and Jennie Lindsay regarding his whereabouts the night before.[154]

Noah fumbled through a series of explanations to investigators. He first claimed that he was in Norfolk to purchase schoolbooks before admitting that he was on Holland Swamp Road late Friday night. He claimed that he was going to see Charley Powell to collect on pay he was allegedly owed.[155] Ferrall and Herrick listened skeptically before asking which of his hands was dominant. Rather perplexed, Noah replied, "Left."[156] Without a solid alibi or witnesses to corroborate his stories, the two police officers took Noah into custody and then conducted a thorough search of the house.

Underneath the eaves, they found a sopping bundle of clothing that was covered in what appeared to be blood. They carefully unwrapped a white cotton shirt, blue vest and matching jacket.[157] Inside the jacket's pocket, they found Alice's missing school sponge. They continued to unwrap the jacket and found three schoolbooks inside: a reading book, a writing book and a spelling book, all saturated in blood and rainwater.[158] Constable Ferrall carefully opened the cover of the reading book. Illegibly scrawled on the inside cover read, "Noah Chry Books Plers don't."[159] Beneath the poorly spelled notation was the name "Alice Powell," written in the little girl's handwriting.

The evidence was just as alarming as it was damning. The investigators took Noah Cherry to the Princess Anne County jailhouse, located near North Landing Road.[160]

Like any small town, word got around rather quickly that this horrible crime had occurred to the most unlikely of victims and that an African American teenager with a bad reputation was arrested for perpetrating it. Those in the Kempsville community were heartsick over the violent, senseless loss of Alice Powell, and their rage was only further fueled by their inherent hatred towards her perpetrator's race. Both the *Norfolk Landmark* and the *Norfolk Virginian* newspapers broke the news of Noah Cherry's arrest, passing prophetic assumptions that the young man wouldn't live long enough to see his trial.[161] To white reporters and locals, it further added to the misconceived stereotype that they held regarding African Americans as brutish, animalistic, "lesser" beings, instead of leading them to examine this as not definitional of race but the incomprehensible act of one angry, unstable boy.

Alice's funeral was held that Sunday at her family's home. People came in from all over the region to convey their sympathies to the heartbroken

Rural Princess Anne County. *Library of Congress.*

family and share in one another's intense fury towards what happened to Alice. Anywhere between 150 and 300 people arrived at the Powells' farm that day. The mob's size, joint emotions and hatred all stirred together a lethal cocktail.[162]

The funeral did nothing but fan the flames already burning in the attendees. At 10:00 p.m., mourners gathered outside the house and transformed into an angry mob. They grabbed anything that could be used as a weapon and appointed an unnamed leader, who demanded vigilante-style justice for the child's death before asking for volunteers to follow him. An hour after forming, the mob banged on the door of the house attached to the jail where Noah Cherry was being held.

Inside, Jailer Murden and his wife woke and stumbled from their bed towards the door. Murden opened it to see a heap of people carrying guns and torches. They demanded that Murden hand over the key to Noah's cell, but he adamantly refused to comply. The mob pushed past him and his frightened wife and marched into the jail. Inside, they found a sleeping Noah Cherry as the jail's only occupant. He was jolted from his cot when the

screaming mob started using sledgehammers to break the mechanism that locked his cell. With every clang of the hammer, he cowered further into the corner. After what must have felt like an eternity for Noah Cherry, the mob managed to break the locking mechanism and wrenched the half-dressed boy out into the cold November night.[163]

Stumbling along the dirt roads wearing only socks, pantaloons and a shirt,[164] the frightened alleged murderer attempted to break free from the flock and run for his life. One of his captors pulled a pistol from his pocket, aimed it towards Noah and fired. The bullet penetrated the boy's arm, the force knocking him to the ground.[165] They grabbed him up and dragged him to a sturdy pine tree located approximately a quarter of a mile from Alice's school. The pine tree had one strong branch that hung directly over the roadway.

The mob leader informed Noah that he only had moments left to live and asked if he cared to confess to his crime. At first, Noah denied the accusations, stating that there was another African American man whom he witnessed killing Alice. A man in the crowd shouted that Alice's schoolbooks were found in Noah's house. Seeing no other choice and with no help in sight, Noah broke down in tears and relayed the story of what actually happened.

He had felt an excessive amount of anger for what he perceived as being unjustly fired by Charley Powell. Wanting to exact revenge, he initially set his sights on hurting Charley. But it was obvious to the scrawny teenager that he was no match for the burly grown man. He turned his attention to what he perceived as the next best option: one of the Powell children. Who better to victimize than Charley's vulnerable ten-year-old daughter? Noah knew her route to school and waited patiently on the side of the road. When he heard her singing, he leapt from the side of the road and attempted to grab her. At first, she didn't cry for help and ran a short distance, attempting to avoid him. She dropped her schoolbooks and lunch basket, but her tiny legs weren't quick enough to escape pursuit. Noah grabbed her and dragged her to the side of the thicket. Alice screamed, "Oh, Lord, have mercy on my soul!"[166] He pulled out an axe and swung it at the girl, nearly severing her neck. He swore that Alice was still making some sort of noises after.

He heard what sounded like someone in the distance heading in their direction. Looking at what he'd done, Noah panicked and grabbed Alice by her feet. He dragged her farther into the woods and waited until he was convinced that she was no longer alive. He emerged from the thicket, ate portions of her discarded lunch and collected her books before heading home.

The mob stood in silence, momentarily in a state of disbelief. Noah looked up and took a deep gulp. He continued confessing to a series of minor crimes throughout the community, such as robbing Mr. Goruter's store.[167] The crowd erupted into angry screams as their leader stepped forward and shoved Noah to the ground. He demanded that the boy pray for a few minutes because those would be the last moments of his life. In a nonsensical, rambling manner, Noah obediently complied.

A makeshift noose was fashioned from a clothesline taken from a nearby farmer's field. Noah's hands and feet were bound together before the noose was slipped around his neck. Those in the mob swung it over the branch and used all their strength to pull Noah from the ground. He let out a small yelp and then began struggling for his life. The leader ordered the armed members of the mob to shoot Noah. They aimed their weapons and fired, riddling his body with bullets. At approximately one o'clock in the morning, Noah Cherry drew his last breath and died.[168] As far as the mob was concerned, justice had been served for Alice. As loud and fervent as they were before the unlawful execution, they were now silent as they dissipated into the night. A local Episcopal minister who observed the lynching later said, "What a comfort to feel that the Almighty is a God of love and mercy as well as Justice."[169]

Later that same morning, newspapers across the South printed praise for the lynch mob's actions. Some headlines even stated how it was a night of "good work" and referred to Noah Cherry in language that would make many twenty-first-century Americans cringe. Not one report readily stated that the mob was wrong for circumventing the legal system. It can't be disputed, the horrible hell that little Alice Powell endured in the last moments of her life and the misery her loved ones must have felt as a result of this heinous crime. However, none of that could ever justify the Kempsville residents' actions in bypassing the legal system that Americans hold so tenderly: the right for *everyone* to have a fair trial.

That afternoon, Princess Anne County Judge Keeding ordered Jailer Murden to cut down Noah's body and proceed with an inquest over what had happened the night before.[170] Bystanders stood around while Murden was cutting Noah's limp body from the tree. They took pieces of the rope that he was strung from as macabre souvenirs. One man stole articles of Noah's clothing and placed them on display at his Market Street business in Norfolk.[171] The evening edition of the *Norfolk Landmark* published: "As we predicted in our last issue, the murderer paid the penalty of his crime Sunday night at the hands of Judge Lynch."[172]

Whether the ordered inquest actually occurred is unknown. Noah Cherry's body was unceremoniously buried in a simple, unmarked grave in the jail's cemetery without any sort of consideration for services or familial presence.[173] Locals expressed relief to be rid of him, stating, "Cherry was of bad stock." Kempsville residents tended to approve of the vigilante justice carried out with Alice Powell's sweet name used as a battle cry for the lynch mob.[174] A North Carolina paper referenced Noah's father and grandfather, stating how he was the third generation in his family to murder someone and die for his crime. It stated, "We hope the last Cherry has dropped from the tree."[175]

Regardless of whether Noah Cherry was actually guilty of the heinous crime he confessed to, true and legal justice had not been served for either him or Alice. In the United States, a defendant is innocent until proven guilty beyond any reasonable doubt in a court of law. Legally, the angry mob, fueled by emotions and driven by wretched hatred towards African Americans, killed an innocent man.

None of this can diminish that Noah Cherry did confess to the violent and senseless murder of an innocent child and should have served the ultimate sentence prescribed by law. But it was not the people's place to end his life before he had his day in court. One can only surmise that had Noah Cherry not been African American, his murderers would have thought twice before dragging him from his cell and lynching him.

BETWEEN 1875 AND 1950, approximately 4,075 racial terror–related lynchings occurred in the southern states.[176] Narrowing the scope to Virginia, between 1880 and 1926, 90 were reported in the Commonwealth.[177] The number was probably far greater, but these incidents were rarely documented due to the blind eye many turned from the direction of racial prejudice–induced violence.

Beyond these deeper legal ramifications, commentary on late nineteenth-century southern Virginia society and the unjust treatment of African Americans throughout American history, the root of this story is not Noah Cherry but Alice Powell. She was an innocent girl who wasn't yet old enough to become accustomed to her culture's hatred towards African Americans. She was a child whose future was violently stolen from her by one angry young man. In 1939, Alice's niece had her body reinterred beside her parents at Forest Lawn Cemetery,[178] where her faded marble headstone remains a haunting relic from a dark day in Princess Anne County's turbulent history.

THE MURDER OF WILDA H. BROKAW

Fort Eustis, Newport News, 1920

Just before nine o'clock on the morning of Friday, January 20, 1920, a shrill cry cut through the serenity, followed by a man's voice screaming for a doctor. Mayme Hunter ran from her home just outside the gates of Camp Eustis in Warwick County towards the direction of the screams. She was joined by James Counts, an African American carpenter who was working on a job in the neighborhood. Mrs. Hunter peered through a side window of the home shared by her neighbors, Wilson and Wilda Brokaw. Inside she spotted Mr. Brokaw, who was hunched over an undefined lump on the floor while clutching some sort of small object in his hand. His hair was unkempt; his face and clothing covered in some sort of dark liquid. Brokaw caught a glimpse of Mrs. Hunter and screamed, "They've been trying to kill her!"[179] She ran from the window to call for help.

SIXTY-TWO-YEAR-OLD WILSON BROKAW MARRIED his beloved wife, forty-nine-year-old Wilda, on November 12, 1896.[180] Their May/December relationship was a loving and devoted one. Wilda never fussed over her husband, and her kind, gentle demeanor naturally eased her into a motherly role to Wilson's young son, Eugene. Wilson was a registered druggist and founded Brokaw Drug Company in Sheldon, Illinois, in 1902.[181] The family lived a happy, successful and largely unremarkable life in and around Chicago.

Around 1904, Eugene noticed subtle changes in his father's behaviors. Wilson was forgetful, began to have trouble sleeping and making decisions and

experienced periods when he had a great deal of difficulty concentrating.[182] As time progressed, Wilson's condition slowly deteriorated. By 1911, he was forced to give up his career and sell his business. Struggling with money, he drank and battled extreme bouts of depression. Despite his emotional and mental health challenges, Wilda remained absolutely devoted to her husband and was his anchor in the increasingly perfect storm inside his mind. Despite great apprehension to leave his parents, Eugene joined the U.S. Army Signal Corps when the United States entered the Great War.

As they were unable to continue to support themselves and with Wilson's mental faculties declining, it was obvious to Eugene that his stepmother needed more help to care for his father than he could provide from afar. In December 1919, he moved his parents to a small cottage just outside the post where he was stationed at Camp Eustis. Their new home was surrounded by other families posted to the command, and the pair were popular fixtures in camp life.[183]

In public, Wilson seemed a perfectly normal, lovable man, and the couple continued to exude their deep affection for each other. Neighbors never

Period depiction of Warwick County. *Library of Congress.*

witnessed even a squabble between Wilson and Wilda. Like most people, their private life was a far different story. Wilson was plagued by increasing paranoia and slept with a pistol beneath his pillow. One night, he was attempting to dislodge a cartridge when the weapon accidentally discharged. Fearing for his parents' safety, Eugene removed the pistol from the home.[184]

It wasn't until the morning of January 20th that the Brokaws' new neighbors and friends were made painfully aware of the challenges the couple faced. Early that morning, Wilson was spotted cleaning his automobile and keeping watch of the couple's dog. He exchanged pleasantries with neighbors as they left for work, and nothing seemed out of the ordinary.

At 8:55 a.m., the cries rang through the neighborhood, spiriting neighbors from their homes. After Mrs. Hunter spotted Wilson through the window and ran to call for a doctor, James Counts entered the Brokaws' cottage. At the foot of the stairs, he discovered the body of Wilda Brokaw lying facedown with her head nestled between her arms, in a pool of her own blood. Wilson continued to scream incoherently while leaning over his wife. The old man was desperate for his wife to speak to him, but all that was uttered was the gurgle of her death rattle.[185]

The camp's physician knew that there was nothing he could do to save Wilda's life. Wilson shuffled to the kitchen while his wife's body was removed from the stairwell. His demeanor shifted from hysteria to decidedly calm. He stared blankly through his gold-rimmed glasses at an unfocused point in the room, unable to acknowledge anyone who entered. Major George von der Hellen, an investigator assigned to Camp Eustis, approached Wilson, taking note of his blood-splattered clothing, hands and forehead.

"What happened to your wife?" Major von der Hellen asked him.

"There have been some negroes hanging around the house, and I don't know anything about it," Wilson muttered.[186] Military police barricaded all entrances to the home and held back the growing crowd that stood in disbelief around the perimeter of the property.

Further inspection revealed that the bathroom's wash basin was stained in blood. Most damning of all was a small, bloodstained carpenter's axe wrapped in butcher paper, found behind the kitchen's coal box. Seeing no other obvious suspect, Major von der Hellen detained an addled and confused Wilson Brokaw for further questioning.

Wilda's autopsy offered a few more details as to what happened to her that morning. She fought for her life against an unknown assailant, with three of

the fingers on her right hand nearly severed by a sharp cleaver. With a final blow to her skull, she died almost instantly. But the "who" and the "why" could not yet be conclusively determined.

Why would Wilson Brokaw kill his wife? There was no reason to believe that they had anything but a happy, loving, affectionate marriage. Mrs. Brokaw was never unfaithful to her husband, and he never had any reason for jealousy. By Wilson's own account, "My wife was a good woman."[187] Though the couple did have financial difficulties, there wasn't a financial motive for Wilson to murder his wife.

Warwick County Sheriff Sydney Curtis arrived at Camp Eustis to transfer Wilson into his custody until jurisdiction could be confirmed. Curtis described him as a man shattered by what was unfolding around him. While on their way to the jail, Curtis obliged the former druggist's request for aromatic spirits of ammonia in order to calm his nerves.[188]

The newspapers dubbed this "the most brutal crime in the post's history." Reporters flocked to the Warwick County Jail as Sheriff Curtis wrestled his prisoner through the sea of flashbulbs and noise. He promised reporters that they would soon be allowed inside to interview his prisoner. Once booked, Wilson shuffled into the room, where the quell had calmed and reporters waited quietly. His dirty gray hair was asunder, a noted juxtaposition to his striking face and long, lean frame. His expression was dazed and distant, as though he was unaware of where he was or that others were even present.

Once seated, one reporter called out, "Mr. Brokaw, is it true that you previously resided in Chicago and Shelden, Illinois?"

"…No," Wilson mumbled without making any sort of eye contact.

There was a baffled hush only sharpened by the scrawl of the reporters' pencils. Another reporter spoke up: "Do you remember when you were married?"

He paused before replying in a faint, muddled mutter, "I…I don't know."

"You do not remember how long you have been married, do you, Mr. Brokaw?" the reporter pressed, incredulously.

"…No."

Reporters continued thrusting questions towards him, but Wilson remained in a daze, appearing as though he couldn't hear what they were saying. Sheriff Curtis stepped in and said, "He is through with you. Let's go back upstairs."[189] Sheriff Curtis gently took the frightened man by the arm, and they left the room. That evening, news reports wove together conspiracy theories and assumptions based simply on Wilson's demeanor throughout the brief interview.

LIEUTENANT EUGENE BROKAW SLUMPED in his chair while listening in utter disbelief as an official from Camp Eustis relayed the news to him. His stepmother had suffered a brutal death, and his father was the primary suspect in her murder. Wilda's remains were transferred from Camp Eustis to W.E. Rouse Funeral Home in downtown Newport News. Eugene was granted emergency leave to accompany his stepmother's remains to Sheldon for burial.

THE STORY OF THE gruesome murder was splashed across the front pages of local newspapers. Headlines described the alleged murder weapon and painted Wilson as a deranged wife-killer. In the court of popular opinion, he had already been tried and convicted before his wife's corpse was even cold.

Eugene attempted to dodge reporters as he made his way to the platform at Lee Hall Depot. While waiting to board the C&O Railroad train to Sheldon, he initially ignored all of their questions. He didn't flinch until one reporter called out, "Lieutenant Brokaw, what motive could your father have had to kill his wife?"

Restored Lee Hall C&O Train Depot. *Nancy E. Sheppard.*

He sharply turned and stared at the reporter. "I know of no motive my father could have had for this deed. I believe it was purely a case of insanity."[190]

DUE TO THE COTTAGE's location on federal property, the Brokaw case was considered in the federal government's jurisdiction, and the trial would be held at the federal criminal court in Norfolk . Despite little concrete evidence to substantially prove his guilt, Wilson Brokaw was indicted on the charge of first-degree murder for the death of his wife. He retained the services of Norfolk attorneys Tazewell Taylor and Ernest S. Merrill to mount his defense. Both were convinced that the circumstantial evidence was stacked against their client and entered a plea of insanity on his behalf. Despite the advice of his legal team, Wilson continued to proclaim his innocence. U.S. District Attorney Hiram Smith[191] refuted the plea, asserting that the defendant was in complete control of his mental faculties.

THAT MAY, WILSON STUMBLED into the courtroom, appearing haggard in his rumpled brown suit and three days' growth of his gray beard. While he was walking up the center aisle of the courtroom, one of his former Camp Eustis neighbors said to him, "We miss you at the camp, Mr. Brokaw."

He let out a meek smile to the woman before replying, "And I miss not being there."[192]

A hush fell over the courtroom as Wilson Brokaw stood to take the stand in his own defense. Attorney Taylor asked him, "Have you any recollection of having done violence to your wife?"

"No, sir. I would not have to hesitate on that; never, at any time."

"Was there any reason you should have done her violence?" Taylor asked the visibly shaken old man.

"There was not."[193]

"What happened that morning, Mr. Brokaw?"

Wilson recalled that he went to the yard early in the morning to do maintenance on his automobile, a story that was corroborated by his neighbors. Afterwards, he took the couple's dog to the ravine behind the house to hunt game. He carried a switch in his hand and, when he approached the house, assumed that this was why his dog refused to go inside the house. Wilson opened a side door and walked in. He heard what sounded like tapping on a window near the front of the house. He assumed

Perspective map of Newport News. *Library of Congress.*

that Wilda locked herself out and was trying to signal to him. He walked around the corner, through the kitchen and into the front entryway. He turned to see the front doorknob shaking lightly. When he attempted to walk into the hallway for further inspection, he found his wife lying on the floor.

"…I discovered my wife lying across the hallway. I went to her and got down on my knees…" Wilson violently trembled and sobbed. "I put my arm around her and made a pillow for her head. I undertook to raise her up… but I could not. I finally did raise her up and stroked her. I tried to get her to talk…she seemed to be struggling. I dropped her down as she lay and went out and called some of the neighbors and asked them to get a doctor. I do not remember the names of the persons I called."[194]

"Did you find the hatchet behind the coal box?" asked Taylor.

"No, I did not, sir." At this point, the defense rested.

Prosecuting Attorney Smith stood gingerly and walked towards the old man, visibly unmoved by the widower's emotional testimony. "Who killed your wife?" he demanded.

"I don't know," was all Wilson could utter.

Major von der Hellen later testified how he discovered the hatchet hidden in the Brokaws' kitchen and that no evidence was ever found to corroborate Wilson's claim that an African American had been stalking about the

property. After Major von der Hellen was dismissed, the gallery watched as Lieutenant Eugene Brokaw took the stand.

He recounted his parents' loving relationship, describing how he was always close with his father and his incredible adoration for his stepmother. When pressed, he described his father's mental decline over the past fifteen years. Smith asked him, "Do you believe that your father killed your stepmother?"

"No. I believe my father is incapable of doing my stepmother injury."[195]

On May 6, 1920, reporters anxiously waited outside the courthouse to hear Wilson Brokaw's fate. Late in the afternoon, it was announced: the defense failed to establish that Wilson was indeed insane at the time of his wife's death and found him guilty of the lesser charge of second-degree murder. Judge Edmund Waddill sentenced him to serve his sentence at the U.S. Penitentiary in Folsom, Georgia, where he remained until his death on December 28, 1922, from a cerebral hemorrhage.[196]

Lieutenant Eugene Brokaw was released from military service and moved back to Sheldon, where he was listed as a telephone worker. In a sad ending to this already tragic family tale, Eugene Brokaw passed away on April 7, 1923.[197]

The question that remains is whether Wilson Brokaw was actually guilty of murdering his wife. By modern standards, the conviction was based on extremely loose and circumstantial evidence. The prosecution failed to present anything concrete or even establish a motive as to why Wilson would have killed his wife. All witnesses testified how devoted and affectionate the couple were with each other. But if Wilson did carry out Wilda's murder, was it premeditated or the byproduct of some sort of neurological or mental health condition that hadn't yet been recognized or better understood in the medical community, such as dementia or Alzheimer's disease? Was there human error in failing to investigate other potential suspects because of the public's fixation on Wilson's peculiar demeanor and physical state at the time of arrest? Was Wilson Brokaw a victim of human perception?

The truth is, we may never know what happened to Wilda Brokaw or whether her beloved husband was truly guilty. It was a case that rocked Hampton Roads but quietly slipped into the vast unknown, leaving the eternal question of whether or not justice had truly been served.

THE MYSTERIOUS DEATH OF ADOLPH COORS

Virginia Beach, 1929

T he Cavalier Hotel, nicknamed Virginia Beach's "Grand Dame," sits at the north end of the oceanfront resort district. It's a tall brick structure that is now mostly obscured by recent condominium developments built on what used to be the hotel's sprawling campus.

The Cavalier has seen a colorful history in its near-century-long life, with a menagerie of guests and circumstances mingling in its elegant corridors. It remained steadfast as the picturesque cottages and the resort's family-friendly, rural appeal was washed away in favor of the modern developments of resorts, bars and souvenir shops. If the Cavalier's walls could talk, one could only wonder of the stories they would tell. Once all of the tourists have returned home and the lights are switched off inside the hotel, a passerby might spot a lamp flicker in a sixth-floor window—an otherworldly salutation from the long-dead beer tycoon Adolph Coors Sr.

Adolph Kuhrs was born in the Rhineland on February 4, 1847. From a young age, he was an apprentice in the traditional art of beermaking. When the military attempted to draft him in 1868, he stowed away on board a transport vessel, illegally immigrating to the United States.[198] After arriving in Baltimore, he traveled to one of the nation's brewery capitals in Chicago and "Americanized" his last name to "Coors."[199] He spent many years working in various positions throughout Chicago-based breweries before deciding it was time to branch off and start his own business.

In 1872, Coors arrived in Denver, Colorado. He met local confectionary shop owner and fellow German immigrant Jacob Schueler. With Schueler supplying the start-up money and Coors contributing his talents and precise business sense, the two purchased an abandoned tannery along Clear Creek in the small Colorado town of Golden.[200] They managed to convert the dilapidated building into a fully functional brewery. During the early years of the business, Adolph would often forego his pay or reinvest it into the brewery's expenses in order to remain not only competitive but also successful.

In 1879, Coors married Louisa Weber, the daughter of the superintendent of the maintenance shops for the Denver & Rio Grande Railroad.[201] In 1880, Coors used what cash he saved and bought out Schueler's stake in the company. With Coors solely leading the helm, he managed to increase his brewery's output from 3,500 to 17,600 barrels per year between 1880 and 1890.[202]

After turning a sizable profit from his business, Adolph built a large mansion for his family with a traditional German biergarten next door. The venue was able to accommodate up to eight hundred guests and was used as a gathering and entertainment spot for Golden's residents. The Coorses opened a public skating rink next to the brewery for their employees and the locals to enjoy.[203] Adolph Coors obtained his American citizenship and was recognized as a respected businessman and philanthropist who was vital to the town's economy as well as a respected husband and father to his six children.

Beneath his reputation was the soul of a shrewd businessman, which carried over into his personal life. His family viewed him as cold, reclusive and a "strict taskmaster."[204] His children found him quite unpleasant to be around, and family time that included their father was often unbearably quiet. Every night at promptly 6:25 p.m., employees at the Coorses' mansion watched as the children lined up in an orderly fashion before entering the dining room for a formal family dinner. As they walked in, they described the children as resembling "little ducks." After sitting down for the meal, Adolph insisted that it was eaten in complete silence.[205] This bizarre display of orderly quiet spoke volumes regarding his dynamic within his family—cold, reclusive, unresponsive and rumored to have used severe corporal punishment on his children.

Everything that Adolph was, his wife was not. Louisa was a kind, gentle, submissive woman who appreciated the beauty in life. She planted flowers all over the brewery's campus and opened greenhouses around the property.

Clear Creek running through Golden, Colorado. *Ken Lund, www.flickr.com/photos/kenlund/5137247119.*

Whenever she was photographed, she either wore or held her favorite flowers: roses.

Regardless of his shrewd demeanor, there wasn't ever any doubt of Adolph's devotion to his company. His acute business sense exponentially grew the brewery's operations each year. In 1894, disaster nearly ruined everything he had spent his life building when a flash flood from Clear Creek nearly washed away the brewery. Adolph Coors used his wealth to his advantage and bought the land across the creek. He forced four families to abandon their homes and paid to have a second channel dug, thus ensuring the safety of his business from future disasters.

Looming on the horizon was a force beyond Adolph Coors's control. The popularity of the ever-growing temperance movement was taking hold in the United States. Despite his wealth and power, he failed to convince Colorado residents not to follow suit. He knew that if his business was to stay not only relevant but afloat, he needed to branch into other divisions. With a $2 million fortune, Coors first invested in real estate and mining. In 1910, he partnered with recent Colorado transplant John J. Herold and formed

Herold Pottery. The company put money into manufacturing porcelain and clayware cookware products that could be used at varying temperatures. The line took off and created another source of revenue for the company. Herold left just two years later, but the products were manufactured under the same name for the next decade.[206]

In 1915, Colorado voted that, beginning in 1916, it would become one of the last "dry" states in the nation. Coors fervently sold as much beer as possible until New Year's Eve. That night, he ordered the remaining 561 barrels dumped into Clear Creek.[207] Family legend states that watching his beer thrown into the creek hurt him so deeply that he never drank it again.[208]

Regardless of temperance, his foresight provided his company with the ability of being one of the few breweries able to stay afloat during Prohibition. Coors started manufacturing a nonalcoholic version of beer called "mannah." This product was produced with the same procedures used for beer but was sent through an additional still that separated the alcohol content from the final product. The alcohol was then sold to the federal government for resale to drug manufacturers and hospitals for legal, medicinal use.[209]

Another profitable venture for Coors was the production of malted milk. This allowed the company to expand outside Colorado, opening divisions in several major cities, including St. Louis, Omaha, Chicago and Dallas. Each division employed a nurse to visit poor mothers in the local community at no charge, providing education and guidance on the importance of proper nutrition for their children.

In 1918, Coors reported that the company's sales and workforce continued to increase, while other pre–prohibition era breweries were going under.[210] All the while he trained his three sons to take over in managing the family business. In 1920, Adolph Jr. took over as CEO of Herold Pottery and changed the name to Coors Porcelain.[211]

By the time federal Prohibition laws went into effect on January 16, 1920, the Coors Corporation was quite pleasantly settled into a new, nonalcoholic routine. Around this time, the family's patriarch started stepping back from his management role. Though he lost some of his fire after the company stopped brewing beer, he retained a heavy interest in its business affairs while following his wife's philanthropic lead in the Golden community. In 1923, he handed over the entirety of his business operations to Adolph Jr.[212] Like his father, Adolph Jr. was a competent and confident businessman, and the company continued to flourish. Despite Adolph Sr.'s nearly obsessive level of control, he willingly ceded it to his son.[213]

One of Adolph Coors Sr.'s original 1873 copper brewing kettles. *Library of Congress.*

In 1927, Coors suffered a particularly difficult bout of influenza. His doctor advised him to take time to visit regions considered more medicinally conducive, like Virginia Beach. Adolph and Louisa visited their children throughout the nation before arriving at the Cavalier Hotel in 1929. Accompanying them were their daughter Louise and their granddaughter.

IN THE EARLY TWENTIETH century, Princess Anne County remained as rural and remote as it was when Alice Powell was murdered many decades before. The county did not receive its first paved road until the 1920s. The Virginia Beach oceanfront could only be accessed via narrow-gauge railroad, which originated in Norfolk. The local gentry kept beautiful weekend cottages along the shoreline. They frolicked in the sand, swam in the ocean and hunted game in Back Bay. But violent storms and hurricanes plagued the coastline, damaging many of the original shorefront attractions, homes and hotels.

In 1926, construction began on a tall, elegant, brick structure composed of half a million bricks. Sitting on a hill at the north end of the resort area, the tower of the hotel overlooked the junction of the Chesapeake Bay and the Atlantic Ocean. Upon completion in 1927, the Cavalier became a hotspot for the rich and famous to play far from the prying eyes of the public. The Cavalier boasted a train depot, with nonstop service as far away as Chicago. Famous early guests included Mary Pickford, F. Scott Fitzgerald and Jean Harlow. The hotel boasted coveted amenities, including an indoor saltwater pool, championship golf course, sunken gardens and stables. When the Coorses arrived in April 1929, the Cavalier was about to open its grandest

Cavalier Hotel, circa 2018. *Nancy E. Sheppard.*

addition of all: the Cavalier Beach Club, which was set to host dances and performances by America's greatest entertainers.[214]

Adolph and Louisa checked into a sixth-floor suite, with their daughter and granddaughter in an adjoining room. The suite had pristine views that overlooked the hotel's ground-level cement patio. Virginia Beach's tranquil atmosphere entranced the brewery tycoon, and his spirits and health seemed to improve considerably. He struck up a friendship with the hotel's stable caretaker, John Woodhouse Sparrow. The two men shared a passion for horses, and Sparrow entertained Coors with his heroic stories as a surf runner, saving people stranded in boats off-shore.[215] The Coors family spent their days relaxing, swimming in the pool and enjoying one another's company. For the first time in his life, Adolph Coors seemed relaxed, happy and personable.[216]

THE MORNING OF JUNE 5, 1929, was typical for Virginia Beach; a light breeze blew off the ocean, tempering the oppressive heat and humidity. The silence of the morning was interrupted by a loud *thunk*, followed by a scream from one of the Cavalier's caretakers. Lying sprawled on the hotel's concrete patio was the crushed body of Adolph Coors Sr. The hotel's management rushed to the Coorses' suite to inform Louisa of their grim discovery. Louisa appeared more perplexed than distraught over her husband's unfortunate demise. She reported that her husband woke early, made his way to the window and, without saying a word, either fell or jumped. Hotel staff noted that all of the suite's doors and windows (including the one that Adolph allegedly fell from) were locked from the inside.[217]

Princess Anne County coroner R.W. Woodhouse arrived at the hotel and examined Adolph's body. After briefly speaking to Mrs. Coors, he determined that no investigation or autopsy was necessary. Officially, the old man died from the injuries he sustained after he fell from his suite's window.[218] Newspapers released the news of his passing, most initially suggesting that he accidentally fell from the window, while some insinuated suicide. The explanation offered over why Adolph may have taken his own life was that he was so distraught over his inability to legally brew beer that he couldn't handle life any longer.

Why would a man who was so focused on not only the growth of his business but also the diversity of it take his own life? His company hadn't brewed beer in well over a decade and was still very profitable. For the first

time in his life, he seemed to have found ease within his success and was able to enjoy the benefits of his hard work.

Some implied that Adolph hadn't accidentally fallen or committed suicide. Instead, something far more sinister happened: he was pushed to his death. As reported by his family, Adolph had a difficult personality and was nearly unbearable to be around, let alone love. He maintained a strong hand and steady control over every aspect of his life. And as much as no one wanted to admit it, maybe someone in his life couldn't take the burden of his standards any longer. Was it his daughter? Was it his wife of fifty years? What happened in that room that morning?

Without the benefit of an investigation or autopsy, it may never be known what actually happened. Witness statements regarding Adolph's recent demeanor and, most damning, the locked windows seem to paint a very different picture than what the coroner reported. Even if Adolph had been a miserable person, did that truly justify murder?

Back in Golden, he was deeply mourned by the community. The town's flags flew at half-mast until after his burial, and his portrait remained hanging in various rooms throughout the brewery he founded. The company continued to pass down through the Coors family for generations, each subsequent owner seeming to have inherited the founder's business acumen.

THE CAVALIER HOTEL HAS watched the years take their toll on the remote beauty that once invited celebrities and tycoons to escape to Virginia Beach's shore. With urban development eating away at the hotel's flourishing grounds, it has become a relic of a bygone era and is dwarfed in the shadows of monolithic chain hotels. In the process of the hotel's current restoration, the new owners hope to resurrect the Cavalier's long-lost elegance from the neglect it endured in the most recent decades of its life. The memories and specters of a forgotten moment of time that saw the hotel's inception are still roaming the halls. Hiding in the aura of the sixth floor, the truth of what happened to Adolph Coors that morning so many years ago remains one of the Cavalier's deepest, darkest mysteries, never to be revealed.

THE TRIAL OF ELISHA KENT KANE III

Hampton, 1931

He was a tall, handsome war veteran from a well-to-do Pennsylvania family. She was a beautiful brunette from Newport News. They appeared to be a glamorous couple, like two movie stars in a seemingly idyllic marriage. But beneath the surface of this glossy exterior lay secrets and strife that were such of a tabloid's fancy and made for brilliant headlines when the tragedy of their twisted love story came to an abrupt end.

ELISHA KENT KANE III sported a thick head of blond hair and steely, attentive gray eyes. He had an aptitude for languages and literature, with a passion for poetry. He was born into the prominent Kane family and raised in the Pennsylvania town named in their honor. Elisha came from the likes of Civil War heroes and Arctic explorers. His own father, surgeon Dr. Evan O'Neill Kane, received notoriety after successfully removing his own appendix.[219] Elisha was the eldest of six sons and had a large extended family. After briefly attending Cornell University, he enlisted in the U.S. Army in 1917. He earned a commission and served active duty until 1920, when he transitioned to reserve status.[220] He kept with his family's adventurous spirit and traveled abroad to teach, translate romance languages and study poetry.

Sometime around 1919, he met and married Jenny Graham, the daughter of a respected Hilton Village justice of the peace.[221] Despite their passionate love for each other, Jenny didn't share her husband's desire to travel. Her parents didn't approve of the soft-spoken poetry and languages professor,

Back River Lighthouse on Grandview Island. *U.S. Coast Guard.*

never hesitating to express this to their daughter. However, the Kanes readily embraced Jenny into their fold, with Dr. Kane treating his daughter-in-law for a heart condition that she hid from her own family.[222]

For the next several years, while Elisha traveled for his career or reserves training, his wife rarely accompanied him. They exchanged letters that expressed a deep affection for each other, using playful pet names and other acknowledgements of their endless devotion to their marriage. In the spaces when they could be together, the two were inseparable, known to lie about in their undergarments while Elisha read love poetry in a variety of languages to Jenny.[223]

The years of living separate lives were not conducive for the longevity of their marriage. Elisha was disheartened by his in-laws' antipathy towards him and was lonely for his wife's companionship while she stayed behind during his travels. In 1929, Elisha met ocean liner employee Betty Harris Dahl. The brunette divorcée physically resembled his absent wife but was more adventurous than Jenny, which complemented his sense of wanderlust. Elisha and Betty entered into a clandestine love affair that he was not certain if he could, or even wanted to, escape from.[224]

Back home, Jenny's heart condition declined and caused her to have fainting spells. Dr. Kane noted that it was due to an "organic defect of the mechanism which kept her heart beating." Jenny confided in him that she had felt it stop a time or two, fearing that the Digitalis she was taking was no longer working.[225]

After returning home, Elisha was concerned about his wife's health. In order to stay put so he could care for her, Elisha accepted a professorship at the University of Tennessee. The couple were soon reunited and moved into a Knoxville apartment. Despite his devotion to and love for his wife, Elisha continued to exchange letters with Betty, even promising to dedicate a book he was writing to "E.H.D."[226] Jenny grew suspicious of her husband's increased emotional distance. After snooping through his belongings, she discovered several of Betty's letters. She confronted Elisha, and he confessed to the affair. She demanded that he end it at once, and he promised to obediently comply. That evening, Jenny wrote to her mother about the affair and the unhappiness she felt.

Elisha ignored all correspondence attempted by Betty and threw himself entirely into rebuilding his wife's trust. By September 1931, their marriage seemed steadily on the mend. As far as Jenny knew, her husband was no longer exchanging letters with the other woman. They planned to visit the Grahams that month in an effort to show a united front to Jenny's family.

Elisha hoped that they would forgive him for the way he had hurt their daughter and that he could somehow bridge the ever-growing chasm between them.

On September 1, a letter arrived at the Kanes' apartment with a return address that only said, "E.H.D." on the back of the envelope. Jenny intercepted the letter, which read:

> My dearest "Sashy,"
>
> There were numerous times, Sashy, when I wondered if you and I would ever get leisure to do some of the "old world" places together—the good and the bad. Do you still have any dreams as my ever being a part of your life? If you ever get rich, would you take me to the "unusual" and would we do the "unusual"?[227]
>
> Where is she? I can't understand how come she stayed home a year. Do you still intend to stick to it?[228] With a little nerve and a very little time, we could get rid of her.[229]
>
> What are you doing with your days this summer, Sashy? I really don't believe I let a day go by without a thought of you. If you were not now at her home you could easily drive to Washington and I could take a bus there.[230]

Jenny did not tell Elisha about the letter and tucked it into her luggage before they left for Newport News. After arriving at her parents' home, Jenny gave Betty's letter to her mother. She expressed concern over a planned outing with her husband to Grandview Island Beach on the eleventh. She was a strong swimmer, but she feared for both her heart's health and that something far more ominous would occur. Elisha assured his wife that everything would be fine and that he would be right there with her if something were to happen.

On the morning of September 11, all seemed fine, and Elisha was especially doting over his wife. They packed their beloved pup into their automobile and set out towards the remote beach in Hampton. They parked their car and headed out to the beautiful beach near Back River Lighthouse.

The stout white lighthouse sat on a jagged pile of rocks near the shoreline. This was a haven for artists and poets to escape from the hustle and bustle of streetcars and automobiles that filled the Peninsula's streets. It was idyllic in its unspoiled visage and remote location. The serenity made it ideal for a couple to find love with each other again—or, perhaps, something else.

The location where Jenny Kane died. *U.S. Coast Guard.*

NOT TERRIBLY LATE INTO the afternoon, a couple of offshore fishermen heard what sounded like a woman screaming, followed by a man's voice crying out.[231] They were too far away to see what was going on or to provide any assistance. The fishermen went about their business, figuring that it was just a young couple doing the things that young couples do in a remote location.

THAT AFTERNOON, PEDESTRIANS ALONG the sidewalks in downtown Hampton watched as a Roadster swerved erratically through the streets before screeching to a halt at Dixie Hospital. A shambolic man climbed out, his eyes wide with panic. He pulled a limp young woman from the passenger side, leaving a barking dog in the front seat. He dashed into the hospital, screaming for someone to help him. The woman had no pulse, so doctors and staff attempted hypodermic injections and to use a pulmotor to revive her, but her body was steadily growing colder. The man begged, "This is my wife! You need to do something! Get another doctor!"

Everyone who attended to her did all that they could, but it was obvious that she was gone. A doctor sat down with the husband and gently informed

him that his wife was gone and then asked for her name. "Jenny...Jenny Kane....I am Elisha Kane....She is my wife...," the man mumbled. The expression on Elisha's face was somewhere between anguish and disbelief. Elizabeth City County Coroner George K. Vanderslice arrived to determine Jenny's cause of death.

Elisha recounted to Mr. Vanderslice how they were swimming near the lighthouse. Jenny dove off the rocks into deep water, but when she surfaced, she started screaming. Elisha swam as quickly as he could to help her, but by the time he reached her, Jenny's head was below water. He pulled her up and struggled while carrying his wife back to shore. He told Mr. Vanderslice that Jenny had a heart condition and that he feared she had suffered some sort of attack.[232] With no one to help, Elisha left her on the beach so that he could retrieve their car. Never for a second did he believe that he couldn't save her.

A sympathetic Mr. Vanderslice looked at the pathetic, grief-stricken widower and told him that an autopsy wouldn't be necessary. From Elisha's account, he determined that Jenny must have had a fatal heart episode and accidentally drowned as a result.[233] He signed her death certificate and released Elisha into the custody of his in-laws.

At the Graham home, Jenny's parents, brother and sister-in-law gathered together in unfathomable grief, but none offered empathy to Elisha. Her heartbroken mother suggested to Mr. Vanderslice that perhaps it wasn't an accident after all, but maybe Elisha killed her daughter. She gave him Betty Dahl's letter, hoping that it would persuade him to change Jenny's official cause of death. Mrs. Graham never expressed her suspicions to her son-in-law as they planned Jenny's unexpected funeral.

Two days later, Jenny Graham Kane was buried in a lonely plot near a brick wall in Historic St. John's Church cemetery. Butterflies were etched onto her simple rectangular headstone with an epitaph from Dante's *Divine Comedy* that reads: "*Nessum maggior dolore, Quel ricordarsi del Tempo felice, Nella miseria*" ("No more pain, That remember the happy time in misery"). This simple, yet poignant, expression best described Elisha's grief. Before the funeral, he packed their belongings and planned to return to Knoxville that evening.

After the service, Elizabeth City County Police greeted Elisha at his in-laws' house.[234] He was placed under arrest for the deliberate and premeditated murder of his wife and taken to the county jail. After being booked into the grimy, overcrowded jail, Elisha asked for paper and a pencil so that he could continue working on his manuscript.[235] It was the

only way he knew how to cope with the unbelievable deficit in his life and the difficult circumstance he was in.

The Grahams didn't waste time disparaging Elisha's character in the press. Jenny's brother made bombastic claims that he had witnessed Elisha abusing a family friend's German shepherd. When the dog was examined, the accusations couldn't be substantiated.[236] Mr. Vanderslice released Betty Dahl's letter to the newspapers, openly admitting that he had changed his mind regarding Jenny's cause of death. Soon thereafter, the original letter was lost and never recovered.

Within a few days of his arrest, Elisha's support arrived from Pennsylvania. His cousins Francis and E. Kent Kane, both Pennsylvania-based lawyers, traveled to Hampton with Dr. Kane. When Francis visited Elisha in his cell, he found his cousin a broken man. His usually well-kept hair was disheveled, and his face was drawn and weary. When Elisha told Francis what had happened, tears violently streamed down his cheeks. "I have tried to tell them exactly what happened on that day when she drowned, but to tell the truth it happened so suddenly that there are some things I don't remember."[237] Francis told Elisha that Dr. Kane was waiting to speak to him in a separate room. Afraid that his appearance would distress his father, Elisha pulled on an overcoat and straightened his hair with his fingers.

Commonwealth's Attorney Roland Cock was set to lead the prosecution. Initially, the Commonwealth asked for Elisha to be denied bail but, due to the lack of concrete evidence, changed the appeal to a bond of $100,000. Judge J. Vernon Spratley ruled that a sum of $15,000 would suffice.[238] The Kane family paid Elisha's bail, and he left prison to wait at Old Point Comfort for trial. Because of the charges, Elisha was forced to resign his position with the University of Tennessee.[239]

Upon the advice of counsel, he granted interviews to reporters who might be sympathetic to his pleas of innocence. On a dreary morning, he sat down over a cup of coffee with *St. Louis Star* reporter Margaret Lane. Instead of the cold-blooded wife-killer she expected to meet, Lane found Elisha to be a pathetic man who had lost absolutely everything meaningful in his life. When she asked if he feared a potential death sentence, he replied, "Physical death is not so terrible to me as life without the things I have lived for....Even if I escape the electric chair, my position, such as it is—is gone, my family disgraced, my wife dead."[240]

The tactic worked, and the public's sympathy for the former professor developed. The Grahams hired a team of lawyers to aid the prosecution in their mission to prove Elisha's guilt in Jenny's death, but the stress and grief

caused Mrs. Graham to have a nervous breakdown, briefly confining her to bed. Newspaper readers salivated over details of the alleged love triangle between Jenny, Elisha and Betty Dahl.

BETTY DAHL FOUND HERSELF at the center of an unwanted controversy because of the secret love affair. She distanced herself as much as she could from Elisha and the public. She retained a Pennsylvania-based lawyer and only spoke to the public through her sister, Ann. Little did the outside world know that Betty was engaged to an unnamed man from Chicago, who promptly ended their relationship when his fiancée's letter to the presumed murderer was released to the public.[241] She hid from the public eye and fell into obscurity.

WHEN THE TRIAL COMMENCED on December 9, 1931, Elizabeth City County's courthouse was a circus of reporters and spectators vying to catch a glimpse of the striking defendant and Jenny's distraught family. Judge Spratley threw an unexpected curveball to the prosecution's case by not allowing Betty Dahl's letter to be submitted into evidence since the original letter had disappeared. The Commonwealth's entire case rested entirely on very loose, circumstantial evidence.[242]

Over one hundred witnesses were called to testify for both the defense and prosecution. Some spoke to Elisha's character, his life and marriage. When Mrs. Graham attempted to testify, she fell apart in desperate, unquenchable sobs before being dismissed and escorted from the courtroom. Next, the Grahams' daughter-in-law took the stand. With a broad brush, she painted the Kanes' life as bedlam. She said Elisha used profanity, professed a disbelief in God and often bragged in front of his wife about his exploits with other women.[243] Elisha retained remarkable composure throughout the trial, but his sister-in-law's testimony was more than he could bear. He leapt from his chair, rushed to Judge Spratley's bench and begged for him to disavow her lies. Judge Spratley instructed Elisha to return to his seat, refusing to hear any more hysteria. Elisha slumped down in his chair and said, "Pardon me, Judge. I've had to stand so much."[244]

Not all the character witnesses were willing to perjure themselves to frame Elisha. University colleagues and several of the couple's friends recounted Elisha as an intriguing colleague and devoted friend and said that the Kanes were tirelessly devoted to each other. What happened with Betty Dahl must

have been what so many do—a grave mistake in a moment of weakness—and was not indicative of the man they knew. After court adjourned for the day, reporters swarmed around the Grahams as they left the courthouse. When they refused to leave Mrs. Graham alone, her daughter-in-law quite literally took matters into her hands, grabbed a photographer's camera and smashed it on the ground.[245]

By December 12, both sides of the case had rested, and the twelve-man jury retired to deliberate at 8:00 p.m. Elisha Kane waited nervously with his family, uncertain what future awaited him, while the Grahams remained confident of a guilty verdict. Impatient outsiders and reporters spoke in hushed tones as the growing crowd around the courthouse spilled over into the street. With the tension at its apex, the jury returned at 11:45 p.m.

Judge Spratley sat silently as he read the jury's decision. He nodded to the foreman, who stood to reveal what everyone was waiting to hear: "We the jury, on the charge of deliberate and premeditated murder of Jenny Graham Kane, find the defendant, Elisha Kent Kane III, not guilty of all

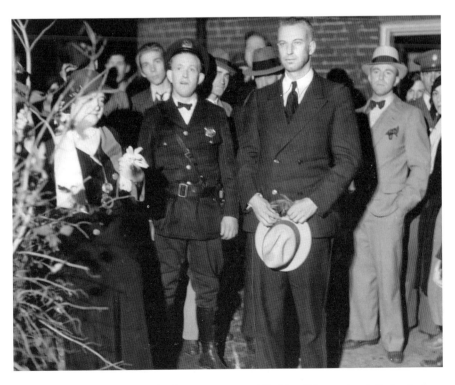

Professor Elisha K. Kane III after he was exonerated for his wife's murder. *Author's collection.*

charges." The cries of anguish from Jenny's family were drowned by cheers of joy from the hundreds of people who crowded the courtroom, hallways and the courthouse's campus. Elisha rose from his chair a freed man and thanked his lawyers, the jury and Judge Spratley.

On the front steps of the courthouse, Elisha stopped briefly to deliver a final statement before he could move on with his life. "It was a terrible ordeal, and I was mighty uncomfortable at times, although I am innocent and believed the jury would so find."[246] Inwardly, Elisha knew that his life would never be the same again.

FROM WHAT CAN BE told, the lives of Elisha Kane, the Grahams and Betty Dahl never again intersected, and Elisha's prophetic words to Margaret Lane regarding the remainder of his life proved correct. His reputation was tarnished by the stigma of having been charged and tried for the murder of his wife. He was unable to obtain another professorship and lacked the desire to continue pursuing the passions that once drove him.

He returned to Kane, Pennsylvania, initially hiding within the folds of his family. When his father passed away the following year, Elisha was named the

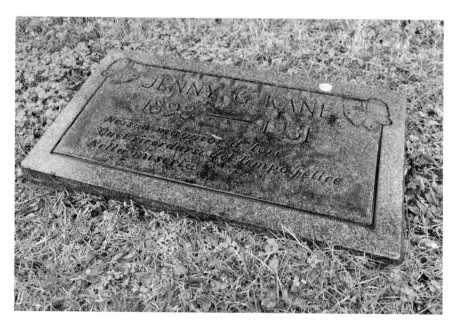

Jenny Kane's grave in Hampton's St. John's Cemetery. *Nancy E. Sheppard.*

sole heir to Dr. Kane's estate and took over his position managing Summit Hospital. In May 1932, Elisha donated his father's home to be converted into the Dr. Evan O'Neill Kane Memorial Sanitarium.[247] He married Mina Gladys Schuler in 1933, and the pair had two children together. In 1941, Elisha returned to active duty and continued with honorable service throughout World War II. He earned the rank of colonel and eventually retired from the U.S. Army.

Elisha Kent Kane III, army colonel, Bronze Star recipient, beloved husband, father of two, admired professor and the man acquitted of the 1931 murder of his first wife, died peacefully in 1959,[248] receiving full military honors at his funeral.

AT THE CENTER OF this story was the young, beautiful Jenny Graham Kane—a woman heartbroken by her husband's affair and whose life was extinguished by an unfortunate accident so long ago. Her grave at St. John's Church cemetery is lonely and forgotten, without flowers or family nearby, and moss is growing along the brick wall next to where her body remains. She was a woman whose death caused so much grief and that her family sought vengeance for in what was billed Hampton Roads' "Trial of the Century," but she has been forgotten to the ages—just another name on a lonely headstone in one of Hampton's most steeped cemeteries.

THE LINDBERGH BABY—CURTIS DECEPTION

Norfolk and York County, 1932

Anne Morrow Lindbergh had the perfect life. The beautiful, intelligent brunette from a wealthy, respected family was accomplished in her own right as a writer and aviatrix. She married America's dashing aviation hero Charles Lindbergh, and on June 22, 1930, their cherub-cheeked baby boy, Charles Lindbergh Jr., was born. With a mop of curly blond hair, a deep-set dimple in his lower lip, chubby cheeks and his slightly misshapen tiny toes, he was the apple of his famous parents' eyes.

The perfection of Anne's life was shattered at 10:00 p.m. on March 1, 1932, when their son's nurse, Betty Gow, came to them in a panic over her horrible discovery: sweet baby Lindbergh was missing from his second-floor nursery of their Hopewell, New Jersey estate. There were traces of mud on the floor that matched shoeprints found outside, and an unsteady, handmade ladder that was broken in two pieces was propped against the white brick wall outside the bedroom window. Left in the baby's nursery was a crudely written ransom note:

Dear sir,

Have 50,000$, 25,000$ in 20$ bills 15,000$ in 10$ bills and 10,000$ in 5$ bills Have them in two packages. Four days we will inform you to redeem the money.

We warn you for making anything public, or for notifying the police, child is in gut care.[249]

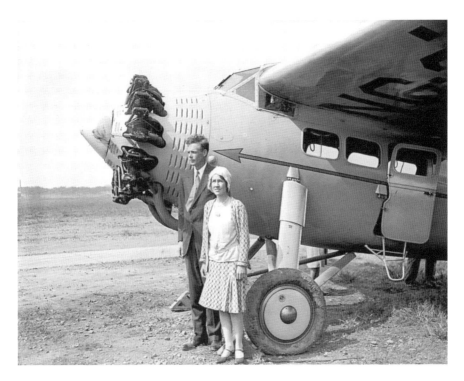

Charles and Anne Lindbergh. *Author's collection.*

What was the Lindberghs' worst nightmare was a dream for sensational journalism. Their agony was scrutinized and documented in intimate detail by a constant barrage of reporters who stalked the Lindberghs, the investigators and anyone remotely related to the case. What unfolded over the next few months was a case that shook the nation to its very core as they sought the perfect baby boy of the first couple of American aviation.

The desperate parents relentlessly followed any leads that they were presented. Charles Lindbergh used his power and persuasion to take charge of the investigation in order to follow the ransom note's explicit instructions not to involve the police or public.[250] He reached out to friends, acquaintances and even the seedy underbelly of society in an attempt to find at least an intermediary to act on the family's behalf to bring little Charlie home.

On March 8, 1932, Dr. James Condon, a retired college professor and strong admirer of Lindbergh, put an offer in the *Bronx Home News* under the pseudonym "Jafsie," attempting to influence the kidnapper to allow him to act as a "go-between." The following day, Dr. Condon received a letter in

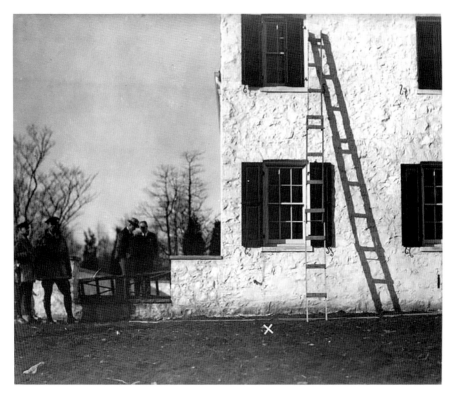

The ladder used by the kidnappers leaning against the Lindbergh estate in Hopewell, New Jersey. *U.S. Department of Agriculture, www.flickr.com/photos/41284017@N08/8004172437.*

handwriting that matched the ransom note accepting his offer. That night, he went to Woodlawn Cemetery in the Bronx and met with a man he called "Cemetery John."[251] Dr. Condon asked that "Cemetery John" provide some sort of evidence to prove that he was who he claimed to be. He told the alleged kidnapper that when he received and confirmed proof, the ransom money would be paid. In a thick European accent Dr. Condon wasn't quite able to place, "Cemetery John" agreed to these conditions. On March 16, Dr. Condon received a package in the mail that contained a freshly laundered Dr. Denton's baby's sleep suit. Betty Gow confirmed that it belonged to little Charlie Lindbergh.[252]

On April 2, Dr. Condon once again met with "Cemetery John" and delivered $50,000 in gold certificates. What the alleged kidnapper didn't know was that not only were gold certificates getting ready to be taken out of circulation,[253] but Colonel Norman Schwarzkopf of the New Jersey State

Police also carefully copied the serial numbers of each bill. He hoped that by distributing the numbers to local merchants, the police force could trace the bills to "Cemetery John" and recover the boy. Before leaving, "Cemetery John" told Dr. Condon that Charlie was being held on board a ship off the coast of Martha's Vineyard in Massachusetts.

NORFOLK SHOULD HAVE BEEN fairly detached from the horrors unfolding in New Jersey. It was in this corner of Hampton Roads that local businessman John Hughes Curtis Sr. lived with his wife, Constance, and their two children. The forty-five-year-old Hampton Roads native had owned his Norfolk-based business, J.H. Curtis Boat & Engine Corporation,[254] since 1917. On the surface, Curtis seemed a well-to-do businessman, was popular in the community and was active in local boat racing. But this was all a façade for the financial challenges Curtis actually faced. With his business falling victim to the financial woes of the Great Depression, he was reliant upon his wife's personal fortune in order to keep it moderately afloat. The family was forced to leave their affluent Algonquin Park home and relocate to an apartment off Redgate Avenue.[255] The strain and pressures of his floundering business and mounting debts, all while caring for his family's needs and status, became maddening and seemed inescapable.

Early on the morning of March 10, 1932, Curtis placed a phone call to Reverend H. Dobson-Peacock, the rector at Norfolk's Christ Church. He asked the minister to come to his home because he had an unusual story to confide in him and needed spiritual guidance. When Reverend Dobson-Peacock arrived later that morning, Curtis relayed the events he claimed occurred the night before. He said that while he was in the parking lot of the marina near his business, he was approached by an unknown bootlegger. This wasn't unusual, considering that his business dealt with all walks of life. The unnamed bootlegger told Curtis that he was working for the gang that kidnapped Charlie Lindbergh and that they wanted him to be the sought-after intermediary. Curtis said he wanted nothing to do with it and asked the reverend's advice on how to proceed. Reverend Dobson-Peacock thought for a moment before saying, "You have no choice. To refuse [to help] would be inhumane. It would cause you to regret the rest of your life."[256]

In what was perhaps an ironic twist of fate, Reverend Dobson-Peacock was personally acquainted with Anne Lindbergh's mother, Mrs. Dwight Morrow. They became acquainted with each other while he served at a church in Mexico City and Anne's father was ambassador to Mexico.[257]

Hinging upon this personal relationship, Curtis reluctantly agreed to take Reverend Dobson-Peacock's advice.

They attempted to reach out to both Charles Lindbergh and his mother-in-law but did not receive a response. The two men called upon Curtis family acquaintance and Norfolk resident Admiral Guy H. Burrage (USN, ret.) for further assistance. The admiral held yet another connection to the Lindberghs. When "Lucky Lindy" made his famous 1927 transatlantic flight to Paris, Admiral Burrage was the commanding officer of American Naval Forces in Europe and was personally charged with escorting Lindbergh back to the United States. The two struck up a friendship and kept in touch after the flight. Burrage mailed a letter to the Lindberghs, informing them that they would arrive at their residence on March 22, 1932. In the meantime, Curtis made a trip to New Jersey to accept the kidnappers' demands and position himself as an intermediary.

When Curtis returned to Norfolk, they flew from Norfolk Naval Air Station to the Philadelphia Navy Yard, where an official navy vehicle waited to take them to the Lindberghs' estate. Upon arrival, they were escorted by state police into Charles's study. The tall, statuesque aviator sat behind his desk, his face drawn from weeks of intense worry and frustration.

Curtis hesitantly introduced himself and launched into a story that seemed absurd to many in the room. But Charles hung onto every word out of Curtis's mouth. He said that he had met with the kidnappers at the Hudson-Manhattan Railroad Station in Trenton, New Jersey, and then went into great detail about their demeanors and appearances. The first man he described was named John, who was Scandinavian and nearly physically identical to Dr. Condon's description of "Cemetery John." The second man was named George Larsen, who was also Scandinavian and slightly older than John. There were three other men named Nils, Eric and Sam. After introductions, the gang directed Curtis to drive them to Larsen's house in Cape May, New Jersey.

On the way, they told Curtis how they kidnapped Charlie. Their motivation was obvious: to extort money from the Lindberghs. They claimed that an unknown member of the Lindbergh household was aiding in their plan. On the night of the kidnapping, they used a handmade ladder to climb into the child's nursery window. When the ladder broke, they panicked. They grabbed the sleeping child from his crib and the inside conspirator aided in maneuvering undetected through the house, carrying Charlie right out the front door. Curtis was assured that the boy was well cared for on a boat off shore, where he was being looked after

by John's German girlfriend, who was also a nurse. Curtis met Larsen's wife, Hilda, whose job was to maintain the two-way radio communication with the kidnappers while they were out on the boat with Charlie and his caretaker. He asked them to prove that they were who they claimed to be. They showed Curtis a few gold certificates, which he was able to verify against the circulated list of serialized ransom bills.[258]

The police officers listening to Curtis's fantastic tale were skeptical. It sounded like a plot from a bad film noir, but Charles Lindbergh couldn't ignore little details that Curtis provided, including the European connection between Condon and Curtis's intermediaries and that Curtis claimed he was able to verify the ransom bills. He felt that there was no reason not to trust Curtis since he was endorsed by a reverend whom his in-laws were personally acquainted with and a navy admiral whom he knew to be a good man.

On March 29, Betty Gow searched outside the Lindbergh estate for anything that could corroborate Curtis's claim that the child was taken from the home through the front door. She made an auspicious discovery by the front walk: an Alice Thumb Guard, matching the ones she attached to Charlie Lindbergh's sleepsuit the night he disappeared.[259] The thumb guard gave Charles Lindbergh even more reason to trust John Curtis, and he encouraged him to find some way to contact the kidnappers.[260] Curtis's friend, E.B. Bruce, a businessman from New York, decided to join him while he awaited further communication from the gang.

Reporters waited like hungry vultures for any news on the case and followed Curtis's every move. He was quoted in the newspapers saying, "I still have hope. I am convinced that I had direct contact with the real kidnapers [sic]…."[261]

Meanwhile, Anne devotedly printed in newspapers a daily recommended diet for her son. Lieutenant George Richard, who was assigned by the U.S. Navy to aid Curtis, joined him and Bruce in New Jersey. On April 19, they accompanied Lindbergh to a Cape May hotel, where Curtis was told to wait for instructions from Hilda Larsen.

Around midnight, Curtis burst into Lindbergh's room, announcing that he was going to meet with the kidnappers that night to deliver the ransom money on board Larsen's boat. He was instructed not to record any of the serial numbers and to come alone.

Lindbergh stayed awake through the night until a weary Curtis arrived back at the hotel later in the morning. He said that the initial meeting took place at Schellinger's Fish Dock. From there, they took a small boat

about fourteen miles offshore, where they boarded a freshly painted eighty-foot vessel. An odd feature about the boat was the way its name was inscribed on it. There were three boards screwed over the top where a ship's name was usually painted. Crudely scrawled on the boards were the words: *Theresa Salvatora*. Curtis demanded to see Charlie, but he was informed that the boy wasn't on board this boat. He was being held on a separate vessel off the coast of Block Island, Rhode Island. He said that they promised to call the Prince George Hotel in New York City the next day to relay instructions on how to retrieve Charlie.[262] Curtis left Cape May and headed to New York City.

The next day, Curtis called Lindbergh with news that a rendezvous location was set. On April 21, Lindbergh chartered a small boat, and the party set sail. They waited patiently, but the other boat never arrived. That evening, they returned to shore, beleaguered and losing hope. Later that night, Curtis received news from Hilda Larsen: the kidnappers never arrived because they feared a trap. For the next rendezvous, they would have to venture far away from New Jersey: to Hampton Roads.

The new location was off the Virginia Capes near York County, approximately twenty miles due east of the Chesapeake Lightship. Curtis was told to search for a black-hulled Gloucester fisherman boat named *Mary B. Moss*.[263] Curtis's friend and owner of Norfolk's Monticello Hotel, Colonel Charles Consolvos, offered the use of his yacht, *Marcon*. He told Lindbergh he could use it and the services of the yacht's captain, Frank Lackmann, for as long as he needed. *Marcon* left that night and sailed right into a storm. Waves crashed violently against the ship's hull, making it difficult to maintain course. A dense fog moved in, which significantly reduced visibility. The ship tossed ferociously in the raging waters, and Lindbergh retreated below deck to rest his queasy stomach. Captain Whiting of Norfolk's Naval Air Station flew a seaplane, searching from air for *Mary B. Moss*. Without any sight of the boat from either Captain Whiting or *Marcon*, Curtis and Lackmann made the decision to turn back.

WHILE CURTIS WAS LEADING Lindbergh on a wild goose chase, letters poured in from all sorts of folks, offering to aid the Lindberghs. One in particular came from the imprisoned Al Capone, who guaranteed the return of the child if Charles Lindbergh would arrange for his temporary release.[264] With Charles tied up with John Curtis and a distraught Anne trying to manage the New Jersey investigation, these offers were largely ignored.

Colonel Charles Lindbergh.
U.S. Naval History and Heritage Command.

OVER THE NEXT WEEK, *Marcon* sailed in and out of port, searching in vain for any sign of *Mary B. Moss*. Every step taken by Charles, Anne and their intermediaries was carefully watched, scrutinized and documented by the press. Curtis kept filling Lindbergh's head with false hope and promises that he claimed were made by the captors, none of which ever came to fruition. He managed to dodge requests from Lindbergh that he or anyone else in their party make contact with the gang, claiming that doing so would risk Charlie's life.

On April 25, Curtis informed Lindbergh that he was leaving Norfolk to fly to New York City in order to meet with Hilda and get a straight answer as to how they could retrieve Charlie. Instead of meeting with the alleged informant, Curtis met with William E. Haskell Jr., the assistant to the president of the *New York Herald Tribune*. Curtis proposed that, in exchange for an unspecified sum of money with a $25,000 advance, he would grant the newspaper the exclusive rights to his story. Haskell readily agreed but under the conditions that the advance would only be paid upon Charlie's

safe return, that the Lindberghs gave their unconditional consent to the story and that the child would be made available for occasional photographs. The two men shook hands and parted ways.[265] Curtis returned to Hampton Roads on April 29.

Skepticism regarding Curtis's story weighed heavily on the others involved with the investigation. While Charles clung to hope, a weary and heartbroken Anne wrote to her mother-in-law on the same day Curtis returned to Hampton Roads:

> *I know I am counting too much just now on Reuben's* [Lindbergh's codename] *lead, and by the time you get this it will probably have fallen through. It has less to recommend it than the majority we follow and everyone I respect (except Reuben who is slightly more hopeful) thinks it is a lot of "hooey," an absolute waste of time, and the sooner they get Reuben clear of it and started on something else, the better.*[266]

On May 2, there was still no progress in retrieving Charlie, so Curtis left on another clandestine venture. Charles felt like a prisoner on board *Marcon* as reporters swarmed the pier. He was distraught and broken and often lashed out regarding the over-involvement of the press in the investigation.

When Curtis returned the next day, he had news that bolstered Lindy's hope: he not only was in touch with the kidnappers, but they relayed a new location where they could retrieve Charlie. He said that the kidnappers decided not to engage in the Virginia meeting because of the heightened public attention drawn to Norfolk. They discussed the new plans with Captain Lackmann, deciding to return to New Jersey on board *Marcon*. From there, they were instructed to go to New York City and wait for Hilda to provide the coordinates for the final meeting.

With hope reignited, *Marcon* spent the next two days sailing north. On May 7, Captain Lackmann went to wake Lindbergh but found that the pilot and his team were gone. In their stead was a note that read: "*Frank—You will hear from me. Please stay here at least two days before you move. Then stand by. Thanks, J.C.*"[267]

Meanwhile, Charles Lindbergh arrived at the Morrows' New York City home and Curtis checked into the Prince George Hotel. On May 8, Curtis met with William Haskell and dictated his story for several hours before abruptly ending the meeting, claiming that he needed to take care of "urgent business."

That evening, Curtis arrived at the Morrows' home. He claimed that he met with Hilda Larsen that day at a cottage on Long Island, where she gave him coordinates off the coast of Five Fathoms Bank near Atlantic City. Charles was elated by the news and gave his wife a special radio code that he could send back to shore once his son was safely returned.

They boarded the eighty-five-foot ketch *Cachalot*, which belonged to one of Curtis's friends. Over the next few days, *Cachalot* spent hours sailing in and out of port, aimlessly wandering through the waters attempting to find the alleged boat from which they were supposed to retrieve Charlie. Curtis told Lindbergh that Hilda informed him that there was discourse between the kidnappers regarding what they should do with Charlie, but they ultimately decided to work together and return the child to his parents.

On May 12, truck drivers William Allen and Orville Wilson were en route to Hopewell with a load of timber. Less than five miles from the Lindbergh estate, the pair pulled over so that Allen could relieve himself in the woods while Wilson waited in the truck. Approximately seventy-five feet from the road, Allen spotted something shiny and white on the ground and leaned down to get a closer look. Horrified, he identified it as a tiny skull, surrounded by thick wisps of curly blond hair. He raced back to the truck and told Wilson what he found. The pair sped to downtown Hopewell and retrieved local police officer Charley Williams.[268]

Officer Williams notified state police and accompanied Allen and Wilson back to the scene. The skull belonged to the badly decomposed body of a tiny boy. The child was wearing an undershirt and flannel diaper, had a deep-set dimple in his lower lip and two toes on the child's right foot abnormally overlapped each other. Both hands and his left leg below the knee were missing from the body. The child's other physical features were difficult to discern, and his skin was black and leathery. Curly wisps of blond hair lay around the skull and were also found in a burlap sack nearby.[269] Most troubling were two fractures found on the skull: a small penetration on the bottom right side of the base and a large crack that ran from the left fontanel to the posterior of the child's left ear. The size and tooth development were consistent with a child approximately twenty months of age. The rate of decomposition in conjunction with New Jersey's climatic conditions indicated that the boy died approximately two to three months prior to his discovery.[270]

While the police were almost certain of the child's identity, they needed further confirmation. They went to the Lindbergh estate and retrieved Betty Gow. She provided a scrap of the fabric she used to fashion Charlie's flannel nightclothes he wore the night he was taken. She also gave a spool of the blue thread used to sew the clothing as well as an undershirt that matched the one he wore. At the police department, she was shown the clothing taken from the body found earlier that day.[271] She positively identified the clothing as belonging to Charlie and asked where the police found it. Betty Gow was the first person outside of the police department to receive confirmation of the devastating news: little Charlie Lindbergh was dead.

AT 5:30 P.M., CURTIS intercepted a coded message addressed to Charles Lindbergh at the Hotel President in Atlantic City. Unable to decipher it, Curtis called E.B. Bruce and Lieutenant Richard to see if they could read it to him. Instead of translating the message for Curtis, Bruce told him that they would be there shortly to deliver the message to Charles in person.[272]

BEFORE DAWN ON THE morning of May 13, Charles Lindbergh arrived at the morgue. He was asked to identify the tiny, darkened corpse found in the woods the day before. When the sheet was pulled back and Charles laid his eyes upon the remains of his tiny son, he fainted and had to be removed from the building. One can only imagine the torrent of emotions that flooded him in that moment. He returned that afternoon with his legal advisor, Colonel Henry Breckinridge. All he could do was ask the coroner if he could have a lock of his child's hair. The media waited outside until the beloved pilot emerged from the building. The tall, once confident hero was reduced to a heartbroken, empty shell of a man as he quietly carried a small pine box to his car.[273] Charles Lindbergh took his baby boy on a final drive to Rosehill Cemetery and Crematory in Linden, where the toddler's remains were cremated.[274]

THE PUBLIC WAS OUTRAGED and mourned the death of aviation's crowned prince. Charles and Anne Lindbergh were in a private hell over the violent loss of their only child and the deceptions that had plagued them since

Charlie's disappearance. All who were involved were held at the Lindbergh estate, forbidden to leave or even speak with anyone off property.

Among the many suspects was John Curtis. No one but Curtis was ever in touch with the alleged group of kidnappers, and he was never able to provide definitive proof of his conversations with the gang. His stories were too inconsistent and unbelievable for New Jersey's seasoned detectives. On May 14, Curtis accompanied detectives as they searched Cape May and Long Island for the houses where Curtis claimed he met with the kidnappers. They drove around for hours, but Curtis was unable to pinpoint the houses that he had previously recounted in intimate detail.

When they returned to the Lindbergh estate, police grilled Curtis over the lack of continuity in his stories. After several hours of harsh questioning, Curtis asked for a typewriter. He sat down at Charles Lindbergh's desk and typed out a statement:

> *At that time I was having a great deal of worry and troubles, which was due to me having a nervous breakdown about a year ago....We were talking in the office and* [someone] *stated that as I knew a number of people who might be interested in* [the crime] *especially rum runners, they probably would not object talking to me about going as a contact between....I think it started to pry on my mind and the more I thought about it the more I was convinced that it might...be able to happen and with that in mind I went to Dean Dobson-Peacock....I told him that I had been approached by this man....It was absolutely just the result of a distorted mind.*[275]

For Charles, it was too unbelievable and unbearable. This man, whom he had every reason to put faith in, confessed that everything he said was nothing more than a fabrication—the boats, people, locations, his mysterious trips… all of it wasn't real. Whatever Curtis's reason, Charles was taken advantage of during the most vulnerable and horrible time in his life. Despite her skepticism in Curtis from the very beginning, Anne shared her husband's devastation over the betrayal.

John Curtis was arrested, charged with obstruction of justice and held at Flemington Jail on $10,000 bail.[276] When his wife and friends in Hampton Roads found out what he confessed to, no one could believe that he was capable of such fabrications. This wasn't at all characteristic of the man they knew and loved. Constance Curtis insisted that the gang must have existed and used John as a patsy to extort money from the famed family.

Reverend Dobson-Peacock stated, "I cannot understand how he could have done such a thing. It just seems impossible."[277] Curtis retained the Norfolk-based attorney W.L. Pender and Flemington-based lawyer C. Lloyd Fisher to mount his defense.[278]

MEANWHILE, POLICE CONTINUED TO interview anyone who may have had even the slightest interaction with the Lindberghs prior to the kidnapping. Violet Sharpe, a maid at the Morrow house, was questioned twice before the police discovered inconsistencies in her story. On June 10, 1932, they arrived at the house to interview Sharpe for a third time. Amid the questioning, she asked to be excused for a moment and retreated to her room. When she did not return, the police searched the house and found her dead. She committed suicide by drinking silver polish that was laced with potassium cyanide. While her alibi was later irrefutably proven, the question lingered why she would have committed suicide if she had nothing to do with Charlie's murder. It can only be assumed that she either knowingly or inadvertently gave the kidnappers information as to the Lindberghs' whereabouts on the evening of March 1 and that she could no longer live with the guilt that she potentially may have aided in the child's murder. Whatever secrets she had, she took to her grave.

A LANDMARK PIECE OF legislation was passed on June 22, 1932: 18 U.S.C. § 1201(a)(1), better known as the "Lindbergh Law." This made kidnapping and other human trafficking offenses that went across state lines not only a felony but also a federal and capital offense. The law's passage did little to soothe the pain felt by Charlie's parents.[279]

IN JULY 1932, JOHN Curtis was tried at the Flemington Courthouse in what was dubbed the "Hoax Trial." The only defense presented on Curtis's behalf were witnesses who testified to his character. However, the evidence against him was damning. Whatever his motivation, be it financial or truly the byproduct of a mad mind, Curtis was convicted of his charges. He was sentenced to imprisonment and fined $1,000.[280] After he paid the fine, he was released and returned to Norfolk that November.[281]

AFTER AN EXTENSIVE INVESTIGATION, Bruno Richard Hauptmann, a German immigrant with a shady past, was arrested in 1935 for the kidnapping and murder of Charlie Lindbergh. The "Trial of the Century" took place at the same courthouse where John Curtis was convicted in 1932. With a case based on largely circumstantial (though damning) evidence, Hauptmann was found guilty of all charges on February 13, 1935, and sentenced to death. The prosecution gave Hauptmann the option to have his sentence reduced to life imprisonment if he named any of his accomplices, but Hauptmann professed his innocence and refused.

On April 3, 1936, at 8:47 p.m., Bruno Richard Hauptmann died in the electric chair.[282] Despite his conviction and execution, the mystery of what happened to precious Charlie Lindbergh continues to be widely debated. Was Hauptmann, in fact, guilty? And if he was, did he act alone? Did Charlie die as a result of an unfortunate accident, or was he brutally murdered? These are questions that may never be answered.

CHARLES AND ANNE LINDBERGH'S lives were forever changed by the trauma of losing their first child. After Charlie's ashes were spread into the sea, their marriage was permanently damaged from the tragic events that unfolded that dark spring in 1932. The couple had five more children and moved to England to provide a sense of safety away from the public eye, where they remained for three years. Charles became an outspoken proponent of the eugenics movement and was never shy to express his admiration for Nazi aeronautical developments, damaging his once-held status as a beloved icon.

Anne found her husband increasingly cold, detached and devoid of emotional involvement with her and their children. The family moved back to the United States upon the outbreak of World War II. Around this same time, Anne became acquainted with fellow author and aviator Antoine Saint-Exupéry. The two carried out a deeply intense emotional affair until 1944, when Antoine died in a tragic airplane accident while performing a reconnaissance mission for France.[283] In her 1955 book, *Gift from the Sea*, Anne alludes to the private pain her life had become. She writes, "The sea does not reward those who are too anxious, too greedy, or too impatient.…One should lie empty, open, choiceless as a beach—waiting for a gift from the sea."[284]

Adding to Anne's anguish, her husband had numerous affairs, fathering at least seven children with three different German women throughout the 1950s.[285]

As for John Hughes Curtis Sr., the Lindbergh case only haunted him for a few years of his life. He was asked to testify at the Hauptmann trial but denied the invitation. In 1938, Curtis appealed to New Jersey Governor Harold G. Hoffman to have his conviction overturned and erased from his record, but his application was denied.[286] Despite the turbulence, Curtis was able to continue his life and returned to work as president of Norfolk's Dunn's Marine Railway. Whether his tall tales in 1932 were the product of a disturbed mind, transpired as he said or somewhere in between will never be known.

In the mid-1950s, Curtis signed a contract on behalf of Dunn's Marine Railway to build the reconstructions of the *Susan Constant*, *Godspeed* and *Discovery* for Jamestown Settlement. In a quote that defined so many aspects of his life, Curtis told the *Daily Press*, "Nobody but me would be darn fool enough to try it."[287] On May 21, 1962, John Hughes Curtis Sr. passed away,[288] leaving his colorful life to history.

Curtis's reconstruction of *Susan Constant* at Jamestown Settlement. *Nancy E. Sheppard.*

THE SAD TALE OF MAJOR JULIAN HARVEY

Newport News, 1944

T he first half of the twentieth century was a golden age for aviation. The fighting in World War II required the United States to mass produce several new planes, including the Consolidated B-24 Liberator, which was built on the same airframe as the U.S. Navy's PB4Y-2 Privateer. With a wingspan of 110 feet and a 68-foot fuselage, the B-24 had an empty weight of 36,500 pounds. The plane boasted ten machine guns and was capable of carrying a bomb payload of approximately 16,000 pounds. With a maximum altitude of 28,000 feet and a range of 2,100 miles, the B-24 initially seemed the next natural progression in aeronautical engineering.[289]

Billed a better flying machine than the famous B-17 "Flying Fortress," the heavy aircraft was riddled with problems. Pilots complained that it was difficult to fly. The most serious challenge that the crews faced was the tendency for the B-24 to break apart and sink within minutes of being ditched in the water. Of the fifty B-24s ditched in the English Channel between 1943 and 1944, thirty-one broke into two or more pieces, drowning approximately 24 percent of the crewmen.[290]

These statistics were daunting and absolutely unacceptable to the U.S. Army, which was not inclined to scrap the planes altogether. Instead, it turned to the National Advisory Committee of Aeronautics (NACA), which was the predecessor to NASA, at Langley Memorial Aeronautical Laboratory in Newport News, Virginia, to improve the existing B-24 design and develop procedures for crews to handle and survive emergency water landings.

After analyzing written reports regarding crashes, NACA flew the B-24 *Ellie Mae* from the warfront to Langley Field in the summer of 1944. Staff took on the grueling task of preparing it for a full-scale ditching experiment. In order to easily ascertain test results, *Ellie Mae* was painted bright yellow with thick black lines along the center of the fuselage. The nose art was covered, leaving just the silhouette of what was once a pin-up girl. Lastly, a "No. 1" was added, indicating that *Ellie Mae* was the first of three planes set for testing. A 1/8-inch steel plate was welded to the plane's underbelly in order to reinforce one of the weaker points of the aircraft's structure.[291] An escape hatch was also added to the roof of the cockpit. The crew complement was reduced from the plane's normal eleven down to just two: a pilot and co-pilot.

Major Julian Harvey was chosen from the U.S. Army Air Corps to pilot *Ellie Mae* on her final flight, with co-pilot Colonel Carl Greene, Langley Field liaison to NACA's laboratory. Harvey was a handsome former model with a thick head of blond hair and a charming smile. He was a qualified and skilled B-24 pilot who distinguished himself in 1942 as one of the first U.S. Army pilots to arrive in England when the United States engaged in the European front of World War II.[292] As part of the Ninety-Third Bomb Group, he flew twenty-nine combat missions over Europe, including participating in the famed Ploesti raids.[293] During his time in Europe, Harvey received the Distinguished Flying Cross and an Air Medal with four Oak Leaf Clusters.[294]

NACA determined that a spot in the James River just parallel to the James River Bridge provided an ideal ditching location. The river's shallower depth of around thirty feet would provide ease in reading test results. Additionally, the bridge would act as a barrier to prevent the plane from floating too far downriver before it could be recovered.

On the morning of September 20, 1944, soldiers and sailors gathered on boats and a barge around the crash site, waiting to photograph and film

Major Julian Harvey. *Author's collection.*

the experiment while providing any aid the pilots may need. The bridge and waterways were closed to civilian traffic, so civilian spectators stood outside, waiting to see *Ellie Mae* pass over.

At Langley Field, *Ellie Mae* weighed in at approximately forty-four thousand pounds. Though officials were initially hesitant to proceed due to foggy conditions, they were reassured by Major Harvey and Colonel Greene as the pilots donned football-style helmets and climbed into the cockpit. *Ellie Mae*'s engines roared to life, and it took off without incident. They flew southwest towards the appointed ditching location, but upon approach, Harvey's visibility was obscured. Around noon, he sped *Ellie Mae* over the shoreline, throttling the engines back to one hundred miles per hour—a barely flyable speed for a B-24. With the triangular landing gear fully retracted, nose pointed in an upward angle and flaps down, Major Harvey and Colonel Greene crashed tail first on target along the river's surface. The onboard instruments registered their speed at the moment of impact at ninety-seven miles per hour, with a deceleration force of 2.6 gs.[295] *Ellie Mae* traveled another 435 feet, as portions of its wing and tail surfaces and two of the plane's four propellers were ripped from its body. It experienced structural failure forward of the wings, showing that the reinforced plating did nothing to prevent the underbelly of a B-24 from shredding apart.[296]

Onlookers anxiously watched while Major Harvey climbed through the escape hatch on the roof of the cockpit, followed by Colonel Greene. Both men took off their helmets, seemingly unharmed. A loud, relieved cheer erupted from the onlookers. While they hadn't managed to save *Ellie Mae*, both pilots were dry and alive. Ever cool and composed, Harvey pulled a comb from his pocket and ran it through his hair. When the pilots were later debriefed, Colonel Greene made it quite clear that the impact they experienced was incredibly fierce.[297] No one could have predicted the violent shift this single incident would cause in Major Harvey's life.

Although he was once a carefree, charismatic man, those who knew Julian Harvey saw a darker person emerge from beneath the surface following the crash landing of *Ellie Mae*. Loved ones mentioned that he developed a stutter that was more prominent when he became agitated.[298] In 1949, he was driving his second wife, Joan, and his mother-in-law, Myrtle Boylen, along the Choctawhatchee Bay in Florida.[299] Inexplicably, he lost control of the vehicle but managed to escape before the car careened off the side of a cliff. His wife and mother-in-law weren't so lucky; both died in the crash.[300] The local judge advocate general cleared Harvey of any wrongdoing.

Ellie Mae after crashing into the James River. *National Aeronautical Space Administration.*

Still on active duty, Major Harvey managed to fly 114 fighter missions during the Korean War. Though his career was successful, his personal life was fraught with tragedy, accidents and degradation. In 1955, he sailed his sixty-foot auxiliary sailboat, *Torbatross*, into the Chesapeake Bay with his son, Lance, and three other passengers on board. When he sailed into the mouth of the Potomac River, the hull of his boat collided with the wreck of the sunken World War I–era vessel *San Marcos*. Harvey had only enough time to send out a distress signal from his quickly sinking boat before needing to evacuate. Harvey and his passengers climbed into a life raft and watched *Torbatross* sink in thirty feet of water.[301] After receiving the distress signal, the navy sent helicopters from a nearby base and rescued the party. All five passengers were miraculously unscathed by the incident, and Harvey later received a settlement from the government for $14,000.

In 1958, Julian Harvey received a medical discharge from the military. Around the same time, his fifth wife filed for divorce. In her divorce petition, she claimed that Julian was frequently unfaithful and that she could no longer tolerate his "secret anger."[302] To add to his troubles, Harvey

experienced a great deal of difficulty holding down a job and was drowning in insurmountable debt.

Julian Harvey's entire world was crashing down on him. He told his friends that he needed a vacation and decided to sail his new eighty-foot yawl, *Valiant*, round trip between Florida and Cuba. Approximately ten miles off the coast of Cuba, the yawl inexplicably caught fire and sank. In yet another apparent fortune of fate, Harvey escaped and safely made it to shore. After returning to the United States, he collected on a $40,000 insurance settlement for the loss of his vessel.[303]

While perusing Florida's beaches, Julian Harvey met attractive TWA stewardess Mary Dene Jordan Smith. Ten years his junior, Mary Dene was swept away by Harvey's charisma, Adonis-like physique, heroic war stories and professions of having substantial wealth. After a whirlwind romance, the couple wed in July 1961.

Before the ink dried on their marriage license, Mary Dene learned the truth about Harvey's wealth, or lack thereof. Their relationship became turbulent, with the couple often fighting over money. Mary Dene promised her father that she would send him $25 a month to help pay for his medical bills. When Julian found out about this, he put a stop to it, causing a permanent rift between his wife and her family. On September 8, 1961, he visited his insurance agent and took out a $20,000 double indemnity life insurance policy on his wife.[304]

In October 1961, Harold Pegg, a Florida businessman, hired the Harveys to crew his ketch, *Bluebelle*. He kept the yacht moored at the Bahia Mar Yacht Basin in Florida and used it as a tourist charter vessel. The agreement was that in exchange for accommodations on board ship and a salary of $300 a month, the Harveys would take over the ship's operations and take Pegg's clients out to sea.

The Harveys had their first chartered clients that November. The Duperrault family from Wisconsin came to Florida for the vacation of a lifetime on board the *Bluebelle*. Dr. Arthur Duperrault was a successful optometrist and had a happy life with his wife, Jean, and their three children, fourteen-year-old Brian, eleven-year-old Terry Jo and seven-year-old Rene. Harold Pegg outfitted *Bluebelle* with twice the safety equipment required by the U.S. Coast Guard and assured the family of its safety. The Duperraults paid Pegg the tidy sum of $515 for the weeklong vacation.

The trip initially proved a wonderful experience for the Middle-American family. Escaping the brutal temperatures of November in Wisconsin, the children enjoyed swimming in the crystal-clear water and playing in the sand.

Meanwhile, Arthur and Jean spent time with the Harveys, finding them to be delightful company. Julian sometimes allowed Arthur to steer the boat, while Mary Dene showed her culinary flair by preparing delicious meals for their passengers. *Bluebelle* was moored at Sandy Point in the Bahamas before they were scheduled to make the overnight journey back to Fort Lauderdale on November 13. Harvey invited seventeen-year-old local fisherman Jimmy Wells to join them on board that night for dinner. Mary Dene served a sumptuous dinner of chicken cacciatore and salad to the guests.[305] After a lovely meal with the Harveys and Duperraults, Wells bid them farewell and disembarked the vessel.

At approximately 5:00 p.m., *Bluebelle* left Sandy Point and sailed into open waters.[306] The only planned stop between Sandy Point and Fort Lauderdale was at Great Stirrup Cay to allow the Harveys a few hours of sleep before the final stretch. At approximately 9:00 p.m., Terry Jo kissed her parents goodnight and headed to the cabin she shared with her younger sister. She was the first to fall asleep in the long, dark night that awaited them.

Fourteen hours later, the crew of the tanker SS *Gulf Lion* spotted what appeared to be a dinghy in the water. Inside the tiny boat was a disheveled man, his blond hair asunder, feet bare and wearing rumpled khaki pants and a dirty floral print shirt. The crew of SS *Gulf Lion* retrieved the dinghy and its passenger. The man inside said, "My name is Julian Harvey....My ship's been lost." He lifted the sail and revealed a second passenger. It was a small, blond girl wearing red shorts and a green shirt. She was cold to the touch and wasn't breathing. The ship's crew determined that the little girl was dead.

The tanker radioed for help from the proper authorities, and soon thereafter, harbor pilot Captain Chris Brown arrived. He oversaw the transportation of Harvey and the little girl's body to shore and investigated the dinghy. Officials from the U.S. Coast Guard sat down to question Harvey over what happened. He recounted an almost unbelievable tale of how a freak squall overtook *Bluebelle* at about eleven o'clock the night before. "I was at the wheel and the others were in the stern. I could not reach them and after I was in the water, I managed to get into a lifeboat."[307]

"What of the girl?"

"It was dark, rough, and squally. I saw a child floating in the water with a life jacket. I pulled it into the lifeboat but the child was dead. I drifted with the body beside me until the tanker picked me up about 1 P.M."[308] Harvey went on to explain how, over the course of just fifteen minutes, the ship encountered the storm, which destroyed the ship's mast. The broken mast

crushed Mary Dene and Arthur Duperrault while also piercing the main fuel line. A fire consumed the ship, making it impossible for Harvey to signal an S.O.S. When asked about the identity of the girl he carried with him, Harvey said that she was eleven-year-old Terry Jo Duperrault.[309]

While newspapers recounted Harvey's tragic tale, U.S. Coast Guard investigators were perplexed by the details. If the fire had occurred so suddenly, then why wasn't Harvey burnt? If his escape was as abrupt as he stated, then why was the dinghy filled with survival gear? They noted that his demeanor seemed unusually calm, given the circumstances. At the end of the interview, Harvey made a comment regarding his passengers that drew the ire of investigators: "I don't have any use for city folks. They're not my kind of people anyhow. They get panicky."[310]

A massive search was underway to find any evidence of *Bluebelle* and its missing passengers. However, the boat sank in one of the deepest stretches of water between Sandy Cay and Fort Lauderdale, at a depth of approximately nine hundred feet of water. It was as though *Bluebelle* just vanished, and any hope of recovering Mary Dene Harvey, Arthur and Jean Duperrault and their two other children disappeared with *Bluebelle*.

ON THE MORNING OF November 16, a freighter located approximately 125 miles off the coast of Miami came across a small life raft drifting aimlessly in the water. Inside sat a dehydrated, badly sunburned blond girl. After pulling the child on board, the captain asked, "What is your name?"

With a parched throat, she was barely able to reply, "Terry Jo Duperrault."[311] The Coast Guard was summoned, and a helicopter carried Terry Jo to Mercy Hospital in Miami.

Julian Harvey was called to the Coast Guard station for further questioning. Upon arrival, he was informed of Terry Jo's miraculous recovery. Harvey said that he was confused about how this could have happened, especially considering that the raft she was found in was tied to the roof of *Bluebelle*'s cabin. He assumed that there was no way that she could have been able to launch it herself.[312] The Coast Guard then

Terry Jo Duperrault after her rescue. *Author's collection.*

pointed out the obvious: the body found in Harvey's dinghy wasn't Terry Jo but her younger sister, Rene. U.S. Coast Guard Lieutenant Ernest Murdoch informed Harvey that an official investigation into the disappearance of *Bluebelle* and its passengers would be launched that day. Harvey excused himself, telling the investigators that he needed to speak to his wife's family. Harvey left an address with investigators where he would be staying and left the station.

JULIAN HARVEY GOT IN his car and drove straight to Miami. At 10:30 a.m. on November 17, he checked into the Sandman Hotel located at 3401 Biscayne Boulevard. Harvey gave owner Fred Hales the pseudonym "John Monroe" and used cash to pay for the room.

A few hours later, motel housekeeper Clara Mae Jackson entered the room rented to "John Monroe." She saw blood on the bedsheets and trickling from beneath the bathroom door. She retrieved Mr. Hales to examine the room. He cautiously approached the bathroom door and knocked. When no one answered, he opened it and found blood smeared along the walls and floor and the naked body of the man he knew as "John Monroe" slumped over on the tile. On the back of the toilet tank sat two photographs: one of Mary Dene Harvey and the other of Julian Harvey's son, Lance.[313]

When police arrived at the room, Investigator B.I. Naylor, who was a personal acquaintance of Julian Harvey, positively identified the fallen war hero. On the dresser, Harvey left a rambling two-page letter, addressed to his friend James Boozer. In the letter, he detailed how he wanted to be buried and asked for James's help in looking after his son. The bottom of the letter was signed with a haunting final message: "I got too tired and nervous, I couldn't stand it any longer."[314]

Harvey left no explanations or apologies for what occurred on *Bluebelle*. Terry Jo Duperrault was the only one left who could reveal the answers regarding what happened on board the yacht. When she was well enough to speak, Terry Jo recounted to investigators what she saw that night:

ON THE LAST NIGHT of their trip, Terry Jo went to her cabin at 9:00 p.m. A few hours later, she awoke when she heard her brother, Brian, screaming, "Help, Daddy, help!" This was followed by the distinct sounds of thumping outside her cabin door. Though riddled with fear, she mustered the courage to leave her bunk. She looked over and saw that Rene was not in her bed.

Julian Harvey's body being removed from the Sandman Hotel in Miami. *Author's collection.*

Terry Jo climbed to the bridge and found the bloody bodies of her mother and brother. Panic-stricken, she ran from the bridge and spotted Julian Harvey. He was carrying a bucket and had a mad look on his face.

"Mr. Harvey, what happened?!" she cried.

Harvey turned sharply towards Terry Jo and growled, "Get down there!" and pointed towards her cabin.[315]

She fled and crouched, frightened, in her cabin for approximately fifteen minutes before Harvey thrust open the door. Terry Jo noticed that he was clutching a rifle in his hand. He stared silently at her for a moment before disappearing into the hallway. Terry Jo could smell fumes and saw water rushing along the floor. She bolted up and followed Harvey on deck. When she caught up with him, she asked, "Are we sinking?"

"Yes!" Harvey threw the end of a rope at her and instructed, "Here, hold this!" The rope was attached to a dinghy that was floating away from *Bluebelle*. Terry Jo fumbled and missed. The two briefly watched as the dinghy disappeared off the port side. Harvey dove into the water and swam away, leaving Terry Jo alone and frightened on the deck of the sinking yacht. Always a resourceful child, she grabbed a cork life ring and climbed on top of the ship's cabin to retrieve the life raft she was later found in.

Terry Jo never saw her father throughout the mayhem nor witnessed Julian Harvey actually murder anyone on the yacht. Her recollection provided investigators with enough answers to surmise what happened. Julian Harvey's rash suicide after learning that Terry Jo was rescued tacitly confirmed to them that he had murdered the other passengers on board *Bluebelle*. Without any way to retrieve the ship or the remains of the missing passengers, the Coast Guard released its official conclusions regarding the case. They surmised that Harvey was desperate for money and attempted to murder his wife for the settlement from the insurance policy he had taken out on her. They assumed that one or more of the Duperraults witnessed Harvey murdering Mary Dene, which is why Harvey killed all but Terry Jo.

But why hadn't he murdered Terry Jo along with the rest of her family? It was assumed that he did not take into account how resourceful the little girl was and thought that she would go down with the sinking vessel.

JULIAN HARVEY WAS BURIED per his request: at sea, wrapped in a red shroud. He wrote that he wished for his body to rest at the same depths as Mary Dene's.

What happened to Julian Harvey that day in 1944 when *Ellie Mae* crashed into the James River? Whatever trauma he endured, it set into motion a chain of events that brought out the worst in a man who, to that point, was supposed to be destined a hero.

THE COLONIAL PARKWAY MURDERS

York, Isle of Wight and New Kent Counties, 1986-1989

Note to the reader: This chapter discusses cases that are still being actively investigated. Out of respect for the families of the deceased and missing, as well as sensitivity to the open investigations, only supplementary images are used.

Throughout the 1980s, a series of mysterious and unsolved murders violated the peace on Hampton Roads' Peninsula. All eight victims were young and taken in pairs, and all of the crime scenes bore striking similarities to one another. To date, these tragic cases remain unsolved. Who committed this series of serial murders that held this sleepy part of the region hostage for several years?

CATHY THOMAS AND BECKY DOWSKI

Cathy Thomas was a twenty-seven-year-old stockbroker who lived in Virginia Beach and worked in Norfolk. A graduate of the United States Naval Academy, Cathy's service brought her to Hampton Roads, and she settled here once her term of service ended.[316] She was in a romantic relationship with twenty-one-year-old College of William and Mary business management major Becky Dowski.[317] Societal taboos wouldn't allow the couple to publicly acknowledge their relationship as anything other than a friendship, but Cathy's family was supportive of their relationship.

On the evening of October 11, 1986, Cathy visited Becky at her Williamsburg dorm. The couple spent some time with friends before deciding to leave campus in Cathy's white Honda Civic,[318] driving in the direction of Colonial Parkway. This dark stretch of road along the coastline between Williamsburg and Yorktown was nicknamed "Lovers' Lane" because its remote location and ample pull-offs made it a go-to spot for couples.

At approximately 6:30 a.m. the next day, a man was jogging along the parkway when he noticed the rear of a small white vehicle jutting out of the bushes along the water's edge.[319] He approached the vehicle and found it unlocked. The jogger opened the trunk and was horrified to find a young woman's body stuffed inside.

Authorities were quick to arrive on scene. Upon further investigation, another woman's body was also found inside the vehicle. Both women's necks were bruised from some sort of ligature and slashed so deeply that one was nearly decapitated. Both were drenched in diesel, and there was evidence of an unsuccessful attempt to set a fire.[320] The woman in the trunk had a piece of nautical line tangled in her red hair, and she clutched in her lifeless fingers a clump of hair that obviously did not belong to either woman.[321]

They were taken to the York County morgue and positively identified as Cathy Thomas and Becky Dowski. Their autopsies revealed that they

The location near where Cathy Thomas and Becky Dowski were found. *Nancy E. Sheppard.*

attempted to fight for their lives, and an investigation determined that neither Becky nor Cathy was killed where they were found. However, without any other forensic evidence, they were at a dead end to find the killer(s). In 1986, forensic science hadn't yet advanced enough so that the hair found in Cathy's hand could be analyzed to conclusively identify DNA.

The Peninsula was shaken; two young women, one a military veteran, the other a promising student at an elite college, had been killed on a stretch of road always thought of as safe. Without concrete leads, the case turned cold. Though the murders permeated local minds, it was considered to be an isolated incident, and ease was gently restored in the community.

DAVID KNOBLING AND ROBIN EDWARDS

Robin Edwards was a fourteen-year-old Newport News girl, described by her family as sweet but fiercely independent. Sowing her rebellious teenage oats, she had a habit of sneaking out and running away to hang out with older kids. She had recently started dating twenty-year-old Hampton resident and medical salesman David Knobling.[322] On the evening of Saturday, September 19, 1987, Robin went to see the movie *Dragnet* with David, his brother and his cousin.[323] After the movie, they took Robin home, though she and David made plans to secretly meet later that night. Sometime after 12:30 a.m., Robin sneaked out of her house and met David in his black Ford Ranger before they drove off into the night.

The next morning, members of the Isle of Wight County Sheriff's Department found an abandoned truck that matched David's in the parking lot of Ragged Island Wildlife Refuge. The doors were unlocked with the radio switched on. Lying on the floor were two sets of underwear, shirts and shoes—one set belonging to a male, the other to a female. A wallet containing David Knobling's driver license was found in the truck's cab.

The sheriff's department called David's father, Karl Knobling, to the scene. He knew that something was wrong because it wasn't like his son to leave his truck unlocked and unattended. The search party spent three days scouring the island's shoreline along the James River. On September 23, Karl's frustrations and hopes were replaced by grief when Robin's body was found lying facedown in the sand. Just fifty yards away lay the body of his son. Also lying facedown, David was shot in the shoulder and also in the back of his head.[324]

The parking lot where David Knobling's truck was found at Ragged Island. *Nancy E. Sheppard.*

Shoreline near where David Knobling and Robin Edwards were found on Ragged Island. *Nancy E. Sheppard.*

No one knew why David and Robin were found so far away from their homes. While Robin's body showed signs of possible sexual assault, three days lying in the tideline washed away any evidence that rudimentary forensic technology could detect. Assumptions regarding the antecedents for their murders ranged from a drug deal gone wrong to a random occurrence of being in the wrong place at the wrong time.

Once again, the Hampton Roads community was shaken. Parallels were drawn between Robin and David's unsolved murders and Cathy and Becky's deaths the year before. However, the ties between the two cases seemed loose. The investigation went cold, and their murders were thrown onto the stack of other unsolved cases. The community soon settled back into a comfortable state of existence while four families grieved.

KEITH CALL AND CASSANDRA HAILEY

Keith Call was the middle of five children. His eldest sister, Joyce, described him as the most stable of her siblings—ambitious and the first of the Call children to attend college.[325] The twenty-year-old met eighteen-year-old Grafton native Cassandra Hailey at Christopher Newport University. After striking up a conversation, Keith nervously asked Cassandra out for a date. She agreed, and they planned it for the evening of April 9, 1988. They started the evening by seeing a movie before attending a friend's party on campus.[326] At approximately two o'clock the next morning, they left the party, and Keith planned to take Cassandra to her parents' house in Grafton.

The next morning, National Park Service rangers found Keith's red Toyota Celica abandoned at the York River overlook, just a few miles from where Cathy and Becky were found two years earlier. The doors were unlocked and keys left in the ignition. Like David Knobling's truck, it appeared to be staged as a stolen vehicle. But there weren't any signs anywhere of either Keith or Cassandra. Searchers scoured the woods, while others took to the water.[327] But it was as though the two simply vanished into the night.

It became clear to investigators that all of these unsolved crimes had connections to one another. The similarities between each case were striking. They were taken in pairs, at some point separated from their vehicles and the last two were staged as though the cars were stolen. But without any leads, witnesses or concrete forensic evidence, the investigation was at a standstill.

Colonial Parkway. *Nancy E. Sheppard.*

While the search continued for Keith and Cassandra, local kids were advised not to "park" along the overlooks. They were told that if they were approached by someone along Colonial Parkway or any other isolated road in the region, even if it was someone appearing to be a police officer, not to respond and immediately drive to the nearest convenience store or populated public place.[328]

Despite an extensive search, Keith and Cassandra have never been found. The Call and Hailey families were left tortured, knowing that their children were out there somewhere, unable to come home.

DANIEL LAUER AND ANNAMARIA PHELPS

By 1989, three separate cases had grown cold under the investigators' fingers. Away from the chaos and scrutiny on the Peninsula, twenty-one-year-old Amelia County native Daniel Lauer was spending Memorial Day weekend with some friends in Virginia Beach. They were visiting Daniel's brother, Clint, and his eighteen-year-old girlfriend, Annamaria Phelps. Clint had

recently lost his job, and the couple was struggling to make ends meet while Daniel was looking for a fresh start in a new town. Clint and Annamaria offered him a place to live in exchange for a small amount of rent. Daniel readily agreed to the arrangement.

At the end of the weekend, Daniel was set to return to Amelia to gather some of his belongings for the move. Annamaria saw it as the perfect opportunity to visit with her family, while Clint stayed behind to job hunt. She spent September 4, 1989, visiting with her family before Daniel picked her up in his Chevy Nova that evening. They decided to drive through the night in order to get back to Virginia Beach. Before saying goodbye to her parents, Annamaria shoved a handwritten note into her pocketbook containing the name and phone number of someone they were set to meet at a rest area in New Kent County. The note also read that the person would be driving a blue van. Why they were going to meet this mystery person is unknown. The pair waved goodbye to Annamaria's family and drove away.[329]

In the early hours of the next morning, Daniel's Chevy was found in the parking lot of the westbound rest area in New Kent County. This was in the wrong direction from where they were heading. The doors were unlocked, and the keys were left in plain view. Daniel's belongings were in the backseat, untouched in the white trash bags he had packed them in. The glovebox was sitting open, and the driver's side window was rolled partially down, with a feathered roach clip hanging on the glass. The tires didn't show any signs of ever leaving the highway.[330] The only item missing from the vehicle was an electric blanket. The scene was eerily similar to Keith Call and Cassandra Hailey's disappearance the year before. Time was of the essence in order to locate Daniel and Annamaria.

Weeks passed, and the warm summer with tourists turned into cool autumn with turkey hunters. During this change of season, there weren't any signs of Daniel or Annamaria. Their families waited patiently for any leads or news on their whereabouts. False sightings and reports came in, but all leads fizzled into nothing.

THE HUNTERS ARRIVED IN the woods around New Kent County for "turkey season." On October 19, 1989, a pair of hunters was walking along a mostly deserted logging road approximately one mile from where Daniel's car was found. On the side of the trail, they spotted something that seemed out of place to the seasoned hunters: an abandoned, ragged electric blanket

sprawled out on the ground. After debating whether to inspect further, one of the men decided to lift the blanket. Underneath, he found two sets of human remains so far decayed that all that was left were two skeletons wrapped in tattered clothing.[331]

The men ran from the scene and called police. When investigators arrived, they snapped photos and scoured the area surrounding the bodies for any evidence. Tangled in leaves along the logging road, they found a delicate locket that Annamaria wore every day. The investigators were soon able to definitively determine that the remains belonged to Annamaria Phelps and Daniel Lauer.

Both sets of remains were taken to the county medical examiner's office to try to determine what happened to them. A small nick was found on Annamaria's fingerbone suggested that she engaged in an intense struggle but was ultimately stabbed, with her cause of death listed as "incised wound from assault."[332] However, due to advanced decomposition, Daniel's exact cause of death could not be adequately determined.[333] Investigators assumed that he must have met the same end as Annamaria.

THE COLD CASES

In the years to follow, all of the investigations remained cold. However, the striking similarities between each case allowed investigators to theorize that they were all somehow related. All were attacked in pairs, separated from their vehicles at some point and taken in remote locations, without concrete forensic evidence left behind. After Daniel and Annamaria's murders, the pattern of killing abruptly ended for reasons investigators and loved ones of the victims can only make assumptions about. The bodies of Keith Call and Cassandra Hailey have never been found. Keith's brother still keeps the same phone number that his parents used in 1987 on the off chance that Keith is still alive somewhere and wants to come home.

But hope can only hold the victims' loved ones for so long, and many of them have relegated themselves to believing that the murders will never be solved and justice will never be served for the eight victims. All that they are left with is an undeniable love for those they lost and a drive to keep pressing on, with an unrepentant refusal to ever allow these cold cases to be forgotten.

On the thirtieth anniversary of Robin Edwards and David Knobling's murders, Karl Knobling sat down with veteran local news reporter Andy Fox. While talking about how he has made it through the years since his son's death, Karl said, "After 30 years and I still miss him."[334]

If you have any information that could help solve the murders of Cathleen Thomas, Rebecca Dowski, Robin Edwards, David Knobling, Daniel Lauer and Annamaria Phelps, and regarding the missing persons cases of Richard Keith Call and Cassandra Hailey, please call your local FBI field office or send an e-mail to colonial_parkway_murders@ ic.fbi.gov.

APRIL FOOLS' DAY PRANK AT MOUNT TRASHMORE

Virginia Beach, 1992

Despite the dark timbre of the previous chapters, it only seems fitting to end with a story of mayhem that is remembered as a somewhat humorous footnote in Virginia Beach history.

MOST CITIES HAVE SOME sort of regional landmark or quirk in which they take great pride. For Virginia Beach, it is a giant pile of trash. That's right; a mountain of refuse is the beloved icon for locals. The city park is an impressive feat in engineering and an early nod to the modern eco-friendly "green" movement. But this beloved piece of roadside Americana was also the backdrop for one of the more infamous scandals in Virginia Beach's rather eccentric history.

MOUNT TRASHMORE WAS THE brainchild of Roland E. Dorer, the former director of the Commonwealth's Department of Health, Insect and Vector Control.[335] He was presented a problem: what to do with a quickly filling trash dump in the center of Virginia Beach? The lifespan of the landfill proved short-lived, it was expensive to maintain and it was considered a blight to the ever-encroaching suburban development along its periphery. It would have been nearly impossible, not to mention fiscally irresponsible, to attempt a move of the refuse somewhere else. A light bulb went off in Dorer's mind: why not transform the landfill into something that could be enjoyed by residents and tourists—like a park?

Mount Trashmore. *Nancy E. Sheppard.*

Of course, this seemed preposterous to city residents. How could a refuse pit be transformed into an enjoyable, let alone safe, space? Dorer worked closely with eco-engineers and presented a plan that compacted the existing trash into vectors of one hundred pounds per cubic foot, with fresh soil used to pad between each cube. Once the cubes were in place, six feet of soil and sod was placed to cap off the entire structure. Tests were taken to ascertain data regarding the park's debris stability, if there was any groundwater contamination and the ability to release potentially harmful gases caused by decaying trash (namely, methane). Engineers devised a plan that placed seven hollow poles at strategic locations around the hill, allowing a slow and steady release of gases at levels that would enable conducive conditions underground while keeping the atmosphere around the structure at healthy, breathable levels.[336]

During construction, neighbors complained of foul-smelling odors and the constant barrage of seagulls swarming around the pit. Officials attempted to deter the gulls by feeding them bread laced with poison, but this proved unsuccessful.[337] Locals dubbed the project with the tongue-in-cheek moniker "Mount Trashmore." City officials balked at the name, with some advocating naming it to honor Dorer. However, to the chagrin of even

its creator, the nickname stuck when the park opened in 1974. In its first year, Mount Trashmore drew 900,000 visitors,[338] and it has become a focal point in the center of the city. Dorer passed away in 1987, leaving the legacy of his innovation for the eco-friendly repurposing of landfills to inspire other parks scattered all over the globe.[339]

Despite becoming a beloved landmark for locals and a destination for tourists, there was still a lot of public apprehension and misunderstanding regarding the stability and healthfulness of the man-made hill. In 1992, the "Bad Boys of Radio," Henry "The Bull" Del Toro and Tommy Griffiths, capitalized on these misconceptions in what would become their infamous "April Fools' Day Prank."

In 1982, Del Toro joined local radio station WNOR-FM99, owned by Tidewater Communications, a subsidiary of Saga Communications out of Grosse Point, Michigan.[340] He built his reputation from his brazen attitude, unpredictable personality and immature, often over-the-top antics.[341] His popularity earned him the coveted spot on the morning drive-time show. Despite running into troubles with the law, including pleading guilty in 1985 to cocaine possession, Del Toro remained a fixture during the most heavily listened to time slot.[342] If anything, his ridiculous stunts and personal troubles served to benefit the station, which drew higher ratings after every incident. In 1990, WNOR-FM99 added Tommy Griffiths to the morning program.[343] While Griffiths was less crass than his partner, he shared Del Toro's nonsensical, immature and often outrageous ideas for their show.

In late March 1992, Tommy suggested that they pull off the ultimate radio prank for the upcoming April Fools' Day: to pay homage to the famed Orson Welles 1938 radio program "War of the Worlds," why not do something similar for their listeners? After convincing news director Gigi Young, program director Buzz Knight and the staff meteorologist to play along, the stunt was set for the April 1 morning program.

At 6:30 a.m., they took to the airwaves and announced that they had just received a report from a University of Virginia seismologist stating that there was a build-up of methane gas beneath Mount Trashmore's surface. As a result, the park was on the verge of exploding.[344] At first, listeners paid little attention to the deejays, accurately assuming that it was just another one of their many pranks.

The station's newscaster reiterated the alleged report, with the staff meteorologist "confirming" Tommy and "The Bull's" announcement. He

went on to also report that there were dirt clouds surrounding the park. Panic ensued among the listener base and local residents. Calls flooded the phone lines at the Virginia Beach Police Department, 911 and other radio stations.[345] Emergency phone lines were so overburdened that many attempting to call in could not get through to emergency services.

Realizing that it was a prank, the Virginia Beach Police Department called the station at 6:45 a.m. and asked that it discontinue broadcasting false information. Instead of complying, Tommy and "The Bull" reported that anyone within a seven-mile radius of Mount Trashmore was in immediate danger of losing their homes and even their lives. They went so far as to provide a list of evacuation routes. Mount Trashmore neighbor Toni Cornelius packed her five-month-old daughter into her car and rushed to a friend's home in Norfolk. While driving past Mount Trashmore, she thought, "What if it blows up right now? My baby!"[346] Parents pulled their children out of school, nearby businesses released their employees and many fled the area, truly believing that their lives were at risk.

City of Chesapeake police arrived at WNOR-FM99 studios at 7:45 a.m., and the broadcast was immediately suspended. Station vice president and general manager Joseph Schwartz drove to the station, unaware of the mayhem his deejays' antics had caused. He recorded an apology message stating, "Tom and Henry have very fertile imaginations. Perhaps they took it to a higher extent than they should have."[347] The message aired throughout the next two days but did little to settle the anger of duped listeners.

As early as the next day, the Federal Communications Commission (FCC) received complaints from angry listeners. One Virginia Beach resident wrote, "I don't understand a kind of humor that makes you laugh by telling you that your home and family may be blown up." Another listener, describing herself as "terrified," wrote: "The irresponsible journalism has caused me and a great many others needless grief, fear and panic."[348]

Grant Goodell, a University of Virginia professor of groundwater geology, issued a statement assuring the public that there was very little chance of what Tommy and "The Bull" suggested ever occurring. He stated, "The chances of it blowing up are extremely small. It would be a smaller chance than the sun not coming up tomorrow."[349] He was also quick to point out that the University of Virginia didn't even have a seismologist on faculty or staff. In fact, the only university seismologists in the Commonwealth were located at Virginia Tech.

WNOR-FM99 faced possible penalties, including fines and possible revocation of its license. After discussing it with the station's parent agency,

"Hugh Mungus" statue in Virginia Beach, circa 1985. *Library of Congress, Prints & Photographs Division, photograph by John Margolies [call number LC-MA05- 3524].*

Joseph Schwartz decided the best course of action was to suspend "The Bull," Griffiths, Gigi Young and Buzz Knight for two weeks without pay. Saga Communications also suspended Schwartz for one week without pay.[350] Claiming an attempt to preserve the confidence of its listeners, the Michigan-based communications company issued a statement stating that it maintained an "obligation to refrain from deliberate distortion or falsification of programming."[351]

In the interim, Mike Arlo filled in during the drive-time slot. He appealed to listeners who called Tommy and "The Bull's" antics irresponsible and immature, while others missed the deejays' ridiculousness.[352] Despite the backlash, the publicity surrounding the stunt proved successful for the station, which saw a substantial ratings boost.[353] To the chagrin of many listeners, the station returned Tommy and "The Bull" to their normal time slot once their suspension was lifted.

On May 11, 1992, the FCC used the stunt as an example to justify amending its rules regarding fabricating broadcasted news. The new regulations stated that companies found to be in violation faced up to a $25,000 fine, no matter what the intentions were. By December, the agency concluded its investigation and issued a statement that, while the broadcast was deemed irresponsible and thoughtless, it was not intended in malice. Thus, a letter of admonishment was placed in WNOR-FM99's permanent file.[354]

That same month, the *Daily Press* released an issue containing its annual "Toadies Awards." The April Fool's Day prank garnered Tommy and "The Bull" a mention, with *Daily Press* staffers stating that the radio station should have played Morris Albert's tedious song "Feelings" on repeat for twelve hours straight instead of the careless prank.[355] The newspaper later declared WNOR-FM99 as the region's worst radio station, calling for station managers to fire specifically Del Toro.[356]

Henry "The Bull" Del Toro remained in the headlines throughout 1993 due to an indictment involving prescription drug fraud while also being successfully sued by a listener whom the deejay pranked eight years prior.[357] In 1995, he left WNOR-FM99 for a drive-time position at rival station, WROX-FM96.1. Tommy Griffiths partnered with Rick Rumble, forming the even more popular morning radio duo of "Tommy and Rumble."

On his new radio program, Del Toro spoke harshly regarding his former radio partner. In response, Griffiths filed a lawsuit, which resulted in an out-of-court settlement of $80,000. In 1997, WROX-FM96.1 fired Del Toro from its lineup. Henry "The Bull" Del Toro never successfully returned

Pole installed into Mount Trashmore.
Nancy E. Sheppard.

to radio. His last job was working as a telemarketer, ironically, just up the hall from WNOR-FM99's studio. Del Toro died in his Norfolk home on June 28, 2002, at the age of forty-four from what were deemed to be natural causes.[358] Tommy Griffiths left WNOR-FM99 in 2009 to pursue other opportunities, with Rick Rumble carrying on the morning show's legacy.[359]

As for Mount Trashmore, the park remains a permanent and prominent landmark for the city. In 1993, four large, hollow flagpoles were added as continued assurance to the public of the park's safety and sustainability. That same year, a large play area named Kid's Cove was opened (and later replaced with an all-abilities, inclusive playground), and a skateboard park was added in the late 1990s. Visitors continue to climb the hill's seventy-two steps to the top, fly kites, watch wildlife and picnic on top of the refuse. In 2002, a rubber cap was added to the surface of Mount Trashmore to continue to ensure the park's environmental protection, with groundwater still being tested monthly.

No matter how much time has passed, Virginia Beach residents still talk about the day that two bad boy deejays managed to convince the public that our cherished engineering marvel was about to destroy everything, forever intertwining Tommy and "The Bull" with a beloved pile of trash.

FINAL THOUGHTS

Hampton Roads remains a pivotal region in American history. It is an area where permanence was established, American democracy was founded, slaves were freed, presidents came, celebrities played, famed aviators learned to fly and lives were forever changed. Underneath the glamorous, heroic surface remain the currents of dark occurrences that, while spoken in hushed whispers, remain crucial in the creation of this corner of the Commonwealth of Virginia.

The stories told in this book are just a handful of the many moments of murder, mayhem, scandal and mystery that have plagued Hampton Roads since its inception half a millennium ago. Ours is a history pockmarked by moments so unfathomable that they were buried in the pages of newspapers and history books in a vain attempt to avoid tarnishing the opulent perception the country had of Hampton Roads.

But like a human life, Hampton Roads is filled with secrets and imperfections that shaped it into the region that we know today. Ours is a geography defined by rivers and landmarked by the military's presence and is a regular melting pot of cultures and societies, struggling, living, breathing and dying next to one another each and every day. Ours is a region defined by its successes yet made human in its darker moments. Hampton Roads remains beautiful beneath the tarnish and is still an Edenic paradise for those who flock to its shores, travel its roads and live and work every day in this community, side by side with one another.

Left: St. John's Church Cemetery. *Nancy E. Sheppard.*

Right: Ferris grave at Historic Oakland Cemetery. *Nancy E. Sheppard.*

In the many memories of those who suffered, those who gave all they had and those we lost along the way, together we have built more than a region but a beautiful, unshakeable home whose strength was formed in our darker moments, instead of the brighter ones.

NOTES

Chapter 1

1. "Colonial Period: Ajacan, the Spanish Jesuit Mission," The Mariners' Museum and Park, last modified 2002, www.marinersmuseum.org/sites/micro/cbhf/colonial/col001.html.
2. Mark St. John Erickson, "A Spanish Outpost on the York Ends in Treachery and Murder," *Daily Press*, September 13, 2013, www.dailypress.com/features/history/our-story/dp-a-spanish-mission-on-the-york-river-ends-in-treachery-and-murder-20130909-post.html.
3. Mallios, "Ajacan," in *Deadly Politics of Giving Exchange and Violence*, 39.
4. St. John Erickson, "Spanish Outpost."
5. "Colonial Period: Ajacan."
6. Mallios, *Deadly Politics*, 38.
7. Ibid., 43.
8. Mark St. John Erickson, "A Lost Spanish Mission on the York River," *Daily Press*, May 8, 2013, www.dailypress.com/features/history/dp-nws-spanish-mission-on-the-york-20130508-story.html.
9. Mallios, *Deadly Politics*, 44.
10. "Colonial Period: Ajacan."
11. Kenneth A. Larson, "U.S. Mission Trail: Virginia Missions," U.S. Mission Trail: The Spanish Missions of the United States, last modified 2017, www.usmissiontrail.com/virginia/index.shtml.

12. St. John Erickson, "Spanish Outpost."
13. Mallios, *Deadly Politics*, 46.
14. Ibid., 45.
15. "Colonial Period: Ajacan."
16. Burch and Stimpson, *American Catholic Almanac*, 276.
17. Larson, "U.S. Mission Trail."
18. Ibid.
19. "Colonial Period: Ajacan."
20. St. John Erickson, "Spanish Outpost."
21. Ibid.
22. Mallios, *Deadly Politics*, 37.
23. Burch and Stimpson, *American Catholic Almanac*, 276.

Chapter 2

24. "Archaeologists Discover the First Physical Evidence of Survival Cannibalism in Colonial America," Jamestown Rediscovery Project, May 1, 2013, www.youtube.com/watch?v=cvwK6mXiVEc.
25. Paula Neely, "Jamestown Colonists Resorted to Cannibalism," *National Geographic News*, last modified May 3, 2013, news.nationalgeographic.com/news/2013/13/130501-jamestown-cannibalism-archeology-science.
26. "Facial Reconstruction of Jane, a Young Female Jamestown Colonist," Jamestown Rediscovery Project, May 1, 2013, www.youtube.com/watch?v=Peegl5RSCKs; Neely, "Jamestown Colonists."
27. Neely, "Jamestown Colonists."
28. Ballard C. Campbell, "'Starving Time at Jamestown' by: Allison D. Carter," in *Disasters, Accidents, and Crises*, 7.
29. Joseph Stromberg, "Starving Settlers in Jamestown Colony Resorted to Cannibalism," *Smithsonian Magazine*, April 30, 2013, www.smithsonianmag.com/history/starving-settlers-in-jamestown-colony-resorted-to-cannibalism-46000815.
30. Rachel B. Herrmann, "The 'Tragicall Historie': Cannibalism and Abundance in Colonial Jamestown," *William & Mary Quarterly* 68, no. 1 (n.d.), accessed December 7, 2017, www.jstor.org/stable/10.5309/willmaryquar.68.1.0047.
31. Andrea Davis, "They Really Drank This Stuff?: A Hard, Queasy Look Inside the Historic Wells of Jamestown Island," *Ideation: A Journal of*

William & Mary College Scholarship & Research, October 2011, www.wm.edu/research/ideation/social-sciences/they-really-drank-this-stuff6752.php.

32. Horn, *Land as God Made It*, 152.
33. Council of Virginia, "A True Declaration of the Estate in Virginia," Jamestown Colony: Virginia Company of London, 1610, www.loc.gov/resource/lhbcb.7018c/?sp=22.
34. Ivor Noël Hume, "We Are Starved," *Colonial Williamsburg Journal*, Winter 2007, www.history.org/foundation/journal/winter07/starving.cfm.
35. Stromberg, "Starving Settlers in Jamestown."
36. "The Jamestown Chronicles Timeline," Jamestown Settlement & American Revolution Museum at Yorktown, last modified 2007, www.historyisfun.org/sites/jamestown-chronicles/timeline.html.
37. Hume, "We Are Starved."
38. Council of Virginia, "True Declaration."
39. Hume, "We Are Starved."
40. Mark Nicholls, "George Percy's A Trewe Relaycon," *Colonial Williamsburg Journal*, Winter 2007, www.history.org/foundation/journal/winter07/a%20Trewe%20Relation.pdf.
41. Hume, "We Are Starved."
42. Stromberg, "Starving Settlers in Jamestown."
43. Ibid.
44. "Cannibalism Confirmed Through Forensic Evidence," Jamestown Rediscovery Project, May 1, 2013, www.youtube.com/watch?v=tZN0UXzCH6g.
45. Hume, "We Are Starved."
46. Ibid.
47. Neely, "Jamestown Colonists."

Chapter 3

48. Rose Altizer Bray, "Virginia Antedates State of Massachusetts in the Matter of Bringing Witches to Trial," *Daily Press*, May 4, 1958, 3D.
49. Cynthia A. Kierner, "Grace Sherwood: The Witch of Pungo," in *Virginia Women*, 21.
50. Ibid., 24.
51. "Witchcraft in Colonial Virginia," Encyclopedia Virginia, last modified February 23, 2012, www.encyclopediavirginia.org/Witchcraft_in_Colonial_Virginia.
52. Kierner, *Virginia Women*, 20.

53. Ibid., 20.

54. Ibid., 21.

55. Ibid., 21–22.

56. Jorja Jean, "Grace Sherwood Didn't Sit Idle as People Accused Her of Witchcraft. She Sued Them," *Virginian-Pilot*, May 10, 2017, pilotonline. com/news/local/history/grace-sherwood-didn-t-sit-idle-as-people-accused-her/article_7c2b7aaf-7b5a-5d66-bce6-46e328b5f00b.html.

57. Kierner, *Virginia Women*, 22.

58. Jean, "Grace Sherwood Didn't Sit Idle."

59. William Homan, "Tale of an Early Virginia Witch," *Scranton Republican*, August 25, 1906, 10.

60. Kierner, *Virginia Women*, 22.

61. Ibid., 22.

62. Jean, "Grace Sherwood Didn't Sit Idle."

63. Kierner, *Virginia Women*, 26.

64. Jean, "Grace Sherwood Didn't Sit Idle."

65. Kierner, *Virginia Women*, 26.

66. Ibid., 27.

67. Homan, "Tale of an Early Virginia Witch," 10.

68. Kierner, *Virginia Women*, 27.

69. Ibid., 27–28.

70. Homan, "Tale of an Early Virginia Witch," 10.

71. Kierner, *Virginia Women*, 28.

72. "Grace Sherwood: The 'Witch of Pungo,'" Virginia Historical Society, accessed January 7, 2018, www.vahistorical.org/collections-and-resources/virginia-history-explorer/grace-sherwood-witch-pungo.

73. Kierner, *Virginia Women*, 29.

Chapter 4

74. Bill Sullivan, "Blackbeard's Head and the Hangman's Noose: What We Really Know about Pirates in Williamsburg," Making History (Presented by Colonial Williamsburg), October 26, 2015, makinghistorynow. com/2015/10/blackbeards-head-and-the-hangmans-noose-what-we-really-know-about-pirates-in-williamsburg.

75. George Humphrey Yetter, "When Blackbeard Scourged the Seas," *Colonial Williamsburg Journal* (Fall 1992), www.history.org/foundation/journal/blackbea.cfm.

76. Sullivan, "Blackbeard's Head."

77. Yetter, "When Blackbeard Scourged the Seas."

78. Ibid.

79. Sullivan, "Blackbeard's Head"; Hugh F. Rankin, "The Pirates of Colonial North Carolina • Appendix I," University of Chicago, accessed January 20, 2018, penelope.uchicago.edu/Thayer/E/Gazetteer/Places/America/United_States/North_Carolina/_Texts/RANPIR/Appendices/1*.html; Kellie Slappey, "The Pirate Blackbeard," North Carolina History Project, last modified 2016, northcarolinahistory.org/encyclopedia/the-pirate-blackbeard.

80. Slappey, "Pirate Blackbeard"; Rankin, "Pirates of Colonial North Carolina."

81. Rankin, "Pirates of Colonial North Carolina."

82. "The Regional Review (1939)," U.S. National Park Service, accessed January 20, 2018, www.nps.gov/parkhistory/online_books/regional_review/vol2-6e.htm.

83. Rankin, "Pirates of North Carolina."

84. Mark St. John Erickson, "Hampton Hangs Two Members of Blackbeard's Crew 295 Years Ago," Dailypress.com, last modified January 27, 2014, www.dailypress.com/features/history/our-story/dp-hampton-hangs-two-members-of-blackbeards-crew-295-years-ago-20140127-post.html.

85. Rick Schmitt, "The Pirate Trials," *Pomona College Magazine*, October 4, 2011, magazine.pomona.edu/2011/fall/the-pirate-trials.

86. Yetter, "When Blackbeard Scourged the Seas."

87. Lee, *Blackbeard the Pirate*, 137.

88. Yetter, "When Blackbeard Scourged the Seas."

89. "Blackbeard's Crew List from 1718," Blackbeard's Realm, accessed January 19, 2018, www.blackbeardsrealm.com/Blackbeard%27s-crew-list.html#.WmJIpahKvIV.

90. Yetter, "When Blackbeard Scourged the Seas."

91. Ibid.

92. Sullivan, "Blackbeard's Head."

93. Yetter, "When Blackbeard Scourged the Seas."

94. Lee, *Blackbeard the Pirate*, 143.

95. Erickson, "Hampton Hangs Two Members."

96. Lee, *Blackbeard the Pirate*, 136.

97. Ibid.

98. Ibid., 137.

99. Ibid.

100. Erickson, "Hampton Hangs Two Members."

101. Yetter, "When Blackbeard Scourged the Seas."

102. Lee, *Blackbeard the Pirate*, 138–39.

103. Ibid., 137.

104. Ibid., 141.

105. Konstam, *Blackbeard's Last Fight*, 73.

106. Lee, *Blackbeard the Pirate*, 139–40.

107. Konstam, *Blackbeard's Last Fight*, 73.

108. Erickson, "Hampton Hangs Two Members."

Chapter 5

109. "Urban Destruction During the Civil War," Oxford Research Encyclopedia of American History, last modified June 8, 2017, americanhistory. oxfordre.com/view/10.1093/acrefore/9780199329175.001.0001/ acrefore-9780199329175-e-313?rskey=ocHm7A&result=4.

110. Mark St. John Erickson, "Burning of Hampton 150 Years Ago Foretold Ferocity of the Civil War," Dailypress.com, last modified August 4, 2015, www.dailypress.com/news/dp-nws-burning-of-hampton-20110806-story.html.

111. Digital Scholarship Lab, "Confederates Burning of Hampton," University of Richmond, last modified 2015, historyengine.richmond. edu/episodes/view/788.

112. Ibid.

113. Francis W. Bird, "Letter from Francis W. Bird to His Sister," University of North Carolina, 1861, blogs.lib.unc.edu/civilwar/index. php/2011/08/15/15-august-1861gen-magruder-carried-about-7-or-8-thousand-soldiers-the-other-day-from-this-place-down-to-hampton-and-burned-the-entire-place/.

114. "Hampton Burnt by the Rebels," *Brooklyn Evening Star*, August 9, 1861, 3.

115. "The Burning of Hampton—Statement of Mr. J. Scofield," *Brooklyn Evening Star*, August 10, 1861, 2.

116. Ibid.

117. "Hampton Is Burned Historical Marker," Historical Marker Database, last modified June 16, 2016, www.hmdb.org/marker.asp?marker=33845.

118. Erickson, "Burning of Hampton 150 Years Ago."

119. "Hampton Is Burned Historical Marker."

120. Digital Scholarship Lab, "Confederates Burning of Hampton."
121. Ibid.
122. Special Correspondent, "Letter from Richmond," *Weekly Advertiser*, August 21, 1861, 2.
123. Ibid.

Chapter 6

124. Parramore, Stewart and Bogger, *Norfolk: The First Four Centuries*, 226.
125. Ibid., 228.
126. Ibid., 226.
127. Office of Secretary of War, *Federal Aid in Domestic Disturbances 1903–1922* (Washington, D.C.: Government Printing Office, 1922).
128. Office of the Historian, "The Civil Rights Bill of 1866," U.S. House of Representatives, accessed February 2, 2018, history.house.gov/Historical-Highlights/1851-1900/The-Civil-Rights-Bill-of-1866.
129. Office of the Secretary of War, *Federal Aid in Domestic Disturbances*.
130. House of Representatives, *Executive Documents Printed by Order of the House of Representatives During the 2nd Session of the 39th Congress* (Washington, D.C.: Government Printing Office, 1867).
131. Parramore, Stewart and Bogger, *Norfolk: The First Four Centuries*, 224.
132. House of Representatives, *Executive Documents*.
133. Ibid.
134. "Latest News by Mail," *Richmond Dispatch*, April 21, 1866, 3.
135. House of Representatives, *Executive Documents*.
136. Office of the Secretary of War, *Federal Aid in Domestic Disturbances*.
137. "The Late Riot at Norfolk," *Baltimore Sun*, April 19, 1866, 1.
138. Parramore, Stewart and Bogger, *Norfolk: The First Four Centuries*, 224.
139. House of Representatives, *Executive Documents*.
140. Office of the Secretary of War, *Federal Aid in Domestic Disturbances*.
141. "Negro Celebration at Norfolk," *Louisville Daily*, April 23, 1886, 1.
142. Ibid.
143. Parramore, Steward and Bogger, *Norfolk: The First Four Centuries*, 225.
144. Ibid.

Chapter 7

145. "A School-Girl Murdered by a Negro," *Staunton Spectator*, November 18, 1885, 2.

146. "Swung from a Tree," *Richmond Dispatch*, November 17, 1885, 2.

147. "School-Girl Murdered by a Negro," 2.

148. Maureen Watts and Jakon Hays, "Grave Marker Hints at Horrific Murder of Alice Powell," *Virginian-Pilot*, last modified February 20, 2014, pilotonline.com/life/article_65bd4a26-aa9e-558b-9172-e4c9ea806650. html.

149. Ibid.

150. "Shocking Tragedy," *Alexandria Gazette*, November 16, 1885, 2.

151. "School-Girl Murdered by a Negro," 2.

152. "Shocking Tragedy," 2.

153. Ibid.

154. "Swung from a Tree," 2.

155. "Shocking Tragedy," 2.

156. Ibid.

157. "Noah Cherry Lynched," *Alexandria Gazette*, November 17, 1885, 2.

158. Gary A. Harki, "10 Notorious Crimes in Hampton Roads History," *Virginian-Pilot*, last modified March 21, 2015, pilotonline.com/news/local/history/150th-anniversary/notorious-crimes-in-hampton-roads-history/article_a685e579-6d5a-5c23-9b2b-d22886c36822.html.

159. "Noah Cherry Lynched," 2.

160. "Hanged by Mob," *New York Times*, November 17, 1885, query.nytimes. com/mem/archive-free/pdf?res=9D07EEDA1E39E533A25754C1A96 79D94649FD7CF.

161. Sachsman, Rushing and Morris, *Words at War*, 383.

162. "Hanged by Mob."

163. Ibid.

164. "A Good Night's Work," *Stark County Democrat*, November 19, 1885, 1.

165. "Swung from a Tree," 2.

166. "Hanged by Mob."

167. "The Murderer of a Little School Girl Lynched," *Peninsula Enterprise*, November 21, 1885, 2.

168. "Lynched for a Horrible Crime," *Green Bay Press-Gazette*, November 17, 1885, 4.

169. Litwack, *Trouble in Mind*, 291.

170. "Virginia News," *Alexandria Gazette*, November 18, 1885, 2.

171. Hall, "Black and White: A Historical Examination of Lynching Coverage."

172. Sachsman, Rushing and Morris, Words at War, 383.

173. "Virginia News," 2.

174. "Swung from a Tree," 2.

175. Rocky Mt. Talker, "Felons for Three Generations," *Almance Gleaner*, November 26, 1885, 2.

176. Capital News Service, "Lynchings: A Shameful Chapter in Virginia History," WTKR.com, last modified May 13, 2016, wtkr. com/2016/05/13/lynchings-a-shameful-chapter-in-virginia-history.

177. Ibid.

178. Watts and Hays, "Grave Marker."

Chapter 8

179. "Brokaw Is to Face Warwick Jury on Charges of Murder," *Daily Press*, January 11, 1920, 1.

180. FamilySearch, Illinois, Cook County Marriages, 1871–1920 (Salt Lake City (Ut.): FamilySearch, 2010), search.ancestry.com/cgi-bin/sse. dll?indiv=1&dbid=2556&h=1253074&tid=&pid=&usePUB=true&_ phsrc=m1k-786972&_phstart=successSource.

181. "News of the Month," *Western Druggist* 24, no. 11 (November 1902): 657.

182. "Brokaw Denies on Stand He Struck Blow Which Caused His Wife's Death," *Daily Press*, May 5, 1920, 2.

183. "Woman's Head Beaten in with Hatchet; Aged Man Held for Wife's Murder," *Daily Press*, January 8, 1920, 1.

184. "Brokaw Denies on Stand," 2.

185. "Brokaw Is to Face Warwick Jury," 1.

186. "Woman's Head Beaten in with Hatchet," 1.

187. "Arraign Brokaw for Preliminary This Afternoon," *Daily Press*, January 10, 1920, 1.

188. Ibid.

189. Ibid., 7.

190. "Son Believes that William H. Brokaw Had Deranged Mind," *Daily Press*, January 9, 1920.

191. "Brokaw Denies on Stand," 1.

192. "Brokaw Is to Face," 1.

193. "Brokaw Denies on Stand," 1.

194. Ibid., 2.

195. Ibid.

196. "Wilson H. Brokaw (1854–1922)," Find A Grave: Millions of Cemetery Records, last modified October 22, 2007, www.findagrave.com/memorial/22378243/wilson-h.-brokaw.

197. FamilySearch, Illinois Deaths and Stillbirths, 1916–1947 (Salt Lake City (Ut.): FamilySearch, 2010), search.ancestry.com/cgi-bin/sse.dl l?indiv=1&dbid=2542&h=907417&tid=&pid=&usePUB=true&_ phsrc=m1k1594968&_phstart=successSource.

Chapter 9

198. Bellant, *Coors Connection*, xiii.

199. Fred Bessier, "Adolph Coors (1847–1929)," Find A Grave, last modified January 1, 2001, www.findagrave.com/memorial/2133.

200. Rich Griset, "Strange Brew," *Coastal Virginia Magazine*, January 2015, www.coastalvirginiamag.com/January-2015/Strange-Brew.

201. Perry, *Colorado Vanguards*, 173.

202. Ibid., 174.

203. Ibid., 173.

204. Bellant, *Coors Connection*, xiii.

205. Perry, *Colorado Vanguards*, 174.

206. Tom Cotter, "20th Century Colorado Pottery," Rocky Mountain Depression Glass Society, last modified May 2014, www.rmdgs.com/wp-content/uploads/2014/05/Colorado-Pottery-article-2-13-2014.pdf.

207. Griset, "Strange Brew."

208. Perry, *Colorado Vanguards*, 174.

209. "Advertisements," *Courier*, July 23, 1929, 7.

210. "'Dry' Colorado Brewery Gains $90,000 Making Malted Milk," *Union Signal* 44, no. 9 (February 1918): 50.

211. Cotter, "20th Century Colorado Pottery."

212. Griset, "Strange Brew."

213. "A. Coors Sr. Passes Away," *Colorado Transcript*, June 6, 1929, 1, www.coloradohistoricnewspapers.org/cgi-bin/colorado?a=d&d=C TR19290606-01.2.9#.

214. "The Cavalier Hotel History," The Cavalier, last modified January 23, 2018, www.cavalierhotel.com/history.aspx.

215. Griset, "Strange Brew."

216. "Motive of Suicide Puzzles Relatives," *Pittsburgh Press*, June 6, 1929, 48.

217. Griset, "Strange Brew."

218. Certificate of Death, Commonwealth of Virginia, for Adolph Joseph Coors (Virginia Beach (Va.): Virginia Department of Health, 1929).

Chapter 10

219. Kimball Payne, "Tale of a Death Lives On in New Book," *Daily Press*, last modified July 20, 1994, articles.dailypress.com/2006-09-10/news/0609100075_1_locals-trial-tale.

220. National Archives and Records Administration, Applications for Headstones for U.S. Military Veterans, 1925–1941 (Washington, D.C.: Records of the Office of the Quartermaster General, Record Group 92, 2012).

221. "Dr. Evan Kane Arrives Home from Hampton," *Kane Republican*, September 19, 1931, 8.

222. Ibid.

223. Payne, "Tale of a Death Lives On."

224. "The Weird Old Lavender Romance Revealed by the Famous Kane Tragedy," *Philadelphia Inquirer*, December 31, 1931, 10.

225. Payne, "Tale of a Death Lives On."

226. "Coroner Holds Elisha Kane Killed Wife," *Ithaca Journal*, September 18, 1931, 5.

227. "Woman, Murder Motive," *Simpson's Leader-Times*, September 18, 1931, 1.

228. "Coroner Holds Elisha Kane Killed Wife," 5.

229. "Woman, Murder Motive," 1.

230. "Coroner Holds Elisha Kane Killed Wife," 5.

231. "Weird Old Lavender," 10.

232. "Dr. Evan Kane Arrives Home," 1.

233. Payne, "Tale of a Death Lives On."

234. Edward B. Lockett, "Professor Kane Set Free after Week in Jail," *Kane Republican*, September 19, 1931, 1.

235. Margaret Lane, "Professor, Held as Slayer, 'Not Afraid of Death,'" *St. Louis Star*, September 23, 1931, 18.

236. Parke S. Rouse, "Sensational Murder Trial Engrossed Peninsula in 1931," *Daily Press*, February 14, 1982, C3.

237. "Dr. Evan Kane Arrives Home," 1.
238. "Kane is Indicted in Wife's Death," *Indianapolis Star*, October 7, 1931, 10.
239. Rouse, "Sensational Murder Trial," C3.
240. Lane, "Professor, Held as Slayer," 18.
241. "Mrs. B.H. Dahl at Hotel Near Philadelphia," *Bradford Evening Star* and *Bradford Daily Record*, September 28, 1941, 1.
242. Payne, "Tale of a Death Lives On."
243. "Home of North Carolina Professor Described as Mad House," *Hope Star*, December 9, 1931, 1.
244. Rouse, "Sensational Murder Trial," C3.
245. Ibid.
246. Ibid.
247. "Kane Sanitarium Badly Damaged by Fire Today," *Warren Times Mirror*, October 6, 1932, 1.
248. National Archives and Records Administration, Applications for Headstones for U.S. Military Veterans.

Chapter 11

249. "CRIME: Never-to-Be-Forgotten (1 of 2)," Time.com, last modified May 23, 1932, content.time.com/time/subscriber/article/0,33009,743741-1,00.html.
250. Larry Klein, "Who Killed Lindbergh's Baby?" NOVA, directed by Larry Klein. Boston, MA: PBS-WGBH, January 30, 2013.
251. Ibid.
252. "Lindbergh Kidnapping," Federal Bureau of Investigation, last modified May 18, 2016, www.fbi.gov/history/famous-cases/lindbergh-kidnapping.
253. Klein, "Who Killed Lindbergh's Baby?"
254. "Building and Boatyard of J.H. Curtis, in 1932," CriticalPast, 1932, www.criticalpast.com/video/65675053626_wooden-boats-in-water_wood-motor-yacht_sail-boats_Storage-Security-Building_Boat-yard_Model-T.
255. Falzini, *Their Fifteen Minutes*, 78.
256. Ibid., 80.
257. Ibid., 78.
258. Fisher, *Lindbergh Case*, 98–100.
259. Ibid., 109; "Lindbergh Kidnapping."

260. "Curtis, Burrage See Lindbergh on Kidnap Case," *Daily Press*, April 12, 1932, 1.

261. "Continues Efforts in Kidnaping [*sic*] Case," *Daily Press*, April 13, 1932, 1.

262. Fisher, *Lindbergh Case*, 100.

263. Ibid., 101–2.

264. "Capone Makes New Offer to Return Baby," *News Leader*, April 23, 1932, 1.

265. Fisher, *Lindbergh Case*, 102.

266. Ibid., 103.

267. Ibid., 103–4.

268. "CRIME: Never-to-Be-Forgotten (1 of 2)."

269. Fisher, *Lindbergh Case*, 109.

270. Falzini and Davidson, *New Jersey's Lindbergh Kidnapping and Trial*, 58.

271. Fisher, *Lindbergh Case*, 109–11.

272. Ibid., 106.

273. "CRIME: Never-to-Be-Forgotten (2 of 2)," TIME.com, last modified May 23, 1932, content.time.com/time/subscriber/article/0,33009,743741-2,00.html.

274. Gardner, *Case that Never Dies*, 89.

275. Falzini, *Their Fifteen Minutes*, 77.

276. Ibid.

277. Fisher, *Lindbergh Case*, 103–6.

278. Falzini, *Their Fifteen Minutes*, 77.

279. "Who Killed Lindbergh's Baby?"

280. Falzini, *Their Fifteen Minutes*, 77–78.

281. "Suspend Sentence on John Curtis in Lindbergh 'Hoax,'" *New Castle News*, November 9, 1932, 8.

282. "Lindbergh Kidnapping."

283. Eric Pace, "Anne Morrow Lindbergh, 94, Dies; Champion of Flight and Women's Concerns," *New York Times*, last modified February 8, 2001, www.nytimes.com/2001/02/08/books/anne-morrow-lindbergh-94-dies-champion-of-flight-and-women-s-concerns.html.

284. Lindbergh, *Gift from the Sea*, 13.

285. "Who Killed Lindbergh's Baby?"

286. "Court of Pardons Refuses to Erase Curtis' Conviction," *Daily Press*, January 7, 1938, 3.

287. "Jamestown Ships Almost Finished," *News Leader*, September 27, 1956, 7.

288. Steve Poole, "John Hughes Curtis, Sr. (1887–1962)," Find A Grave, last modified June 8, 2009, www.findagrave.com/memorial/38101111/john-hughes-curtis.

Chapter 12

289. "Deliberate Ditching in the James," Newport News Shipbuilding Apprentice School Organizations, accessed January 1, 2018, www.nnapprentice.com/alumni/letter/Deliberate_Ditching_in_the_James.pdf.
290. Ibid.
291. Ibid.
292. J. Raymond Long, "B-24 'Ditched' to Experiment on Structures," *Daily Press*, September 21, 1944, 1.
293. John Dowdy, "Capt. Julian A. Harvey (1917–1961)," Find A Grave, last modified March 15, 2013, www.findagrave.com/memorial/106731967.
294. Long, "B-24 'Ditched' to Experiment," 2.
295. "Deliberate Ditching in the James."
296. "B-24 Liberator: 'Ditching of a B-24 Airplane into the James River,' 1944 NACA World War II," YouTube, March 23, 2013, www.youtube.com/watch?v=WjadMxpXprk.
297. Long, "B-24 'Ditched' to Experiment," 2.
298. William Tucker, "Profile of Death Skipper," *Miami News*, November 19, 1961, 9.
299. "Grim Tragedy at Sea and Suicide," *Pensacola News Journal*, November 18, 1961, 1.
300. Dowdy, "Capt. Julian A. Harvey."
301. "Copters Pull 5 from Sea," *Akron Beacon Journal*, October 22, 1955, 3.
302. Ron Franscell, "Alone in a Dark Sea," in *Delivered from Evil*, 244.
303. Ibid.
304. Ibid., 245.
305. Ibid., 246.
306. "Bodies of Five Being Hunted after Sinking," *Tallahassee Democrat*, November 14, 1961, 1.
307. Ibid.
308. Ibid.
309. Franscell, *Delivered from Evil*, 248.
310. Ibid.

311. Sanford Schneir, "Little Girl Is Found on Raft at Sea," *Miami News*, November 16, 1961, 21.

312. "Grim Tragedy at Sea," 8a.

313. "Boat Disaster Captain Takes Own Life," *Tampa Bay Times*, November 18, 1961, 1.

314. Ibid.

315. Franscell, *Delivered from Evil*, 247–48.

Chapter 13

316. Joanne Kimberlin, "'The Killer Could Still Be Out There': 30 Years Later, Still No Answers in the Colonial Parkway Murders," *Virginian-Pilot*, last modified October 8, 2016, pilotonline.com/news/local/crime/article_a7918d4c-8305-54e2-a645-5da3ce8e2f6c.html.

317. David Lohr, "Controversial Figure in Colonial Parkway Murders Arrested," Huffington Post, last modified December 6, 2017, www.huffingtonpost.com/2011/09/06/fred-atwell-colonial-parkway-murders-arrest_n_947121.html.

318. Andy Fox, "Special Report: The Colonial Parkway Murders—30 Years Ago," WAVY-TV, October 12, 2016, wavy.com/2016/10/12/special-report-the-colonial-parkway-murders-30-years-ago.

319. Virginia Department of Health, Certificate of Death for Cathleen Thomas (Richmond: Virginia Department of Health, 2015).

320. Kevin Green, "The Colonial Parkway Murders: A Special Kind of Evil," WAVY-TV, last modified September 22, 2017, wavy.com/investigative-story/the-colonial-parkway-murders-a-special-kind-of-evil.

321. Fox, "Special Report."

322. Virginia Department of Health, Certificate of Death for David Knobling (Richmond: Virginia Department of Health, 2015).

323. Andy Fox, "The Search for David & Robin," WAVY-TV, September 23, 1987, wavy.com/investigative-story/the-colonial-parkway-murders-a-special-kind-of-evil.

324. Green, "Colonial Parkway Murders."

325. Kimberlin, "Killer Could Still Be Out There."

326. Brendan Ponton, "Unsolved: Still No Sign of Young Couple 28 Years after Car Found along Colonial Parkway," WTKR.com, last modified November 2, 2016, wtkr.com/2016/11/01/unsolved-still-no-sign-of-young-couple-28-years-after-car-found-along-colonial-parkway.

327. Ibid.

328. Midkiff, personal interview.

329. Blaine L. Pardoe, "Anniversary of the Fourth and Last of the Colonial Parkway Murders? Daniel Lauer and Annamaria Phelps," Notes from the Bunker, September 2, 2017, blainepardoe.wordpress.com/2017/09/02/anniversary-of-the-fourth-and-last-of-the-colonial-parkway-murders-daniel-lauer-and-annamaria-phelps/.

330. Green, "Colonial Parkway Murders."

331. Pardoe, "Anniversary of the Fourth and Last."

332. Virginia Department of Health, Certificate of Death for Annamaria Phelps (Richmond: Virginia Department of Health, 2015).

333. Virginia Department of Health, Certificate of Death for Daniel Lauer (Richmond: Virginia Department of Health, 2015).

334. Andy Fox, "The Colonial Parkway Murders: 30 Years Later," WAVY-TV, September 21, 2017, wavy.com/investigative-story/the-colonial-parkway-murders-30-years-later.

Chapter 14

335. Aaron Applegate, "What's in a Name?: Mount Trashmore in Virginia Beach," *Virginian-Pilot*, last modified June 7, 2010, pilotonline.com/news/local/history/article_c383b5d6-68ca-5d02-a1e2-830cf903d404.html.

336. Sarah Hartough, "Mount Trashmore," Baltimoresun.com, last modified February 10, 2015, www.baltimoresun.com/travel/beaches/bal-bab-vatrashmore-story.html.

337. Applegate, "What's in a Name?"

338. Hartough, "Mount Trashmore."

339. Applegate, "What's in a Name?"

340. Jakon Hays and Maureen Watts, "The Best April Fools' Hoax in Hampton Roads History? The Mt. Trashmore Explosion," *Virginian-Pilot*, last modified April 1, 2016, pilotonline.com/news/local/history/back-in-the-day/article_dcd70532-01ca-5712-acce-ccfdb2a590e2.html.

341. Bob Blattner and David Nicholson, "Indicted Radio Personality to Stay on Air," *Daily Press*, April 7, 1993, B3.

342. Mike Holtzclaw, "Radio's 'Bad Boy' Del Toro Dies, 44," DailyPress.com, last modified June 30, 2002, articles.dailypress.com/2002-06-30/news/0206300221_1_henry-del-toro-on-air-stunts.

343. Lauren King, "Tommy Announces He's Leaving 'Tommy and Rumble' Show," *Virginian-Pilot*, last modified November 6, 2015, pilotonline.com/news/tommy-announces-he-s-leaving-tommy-and-rumble-show/article_c1c0aa6c-315d-5da9-a939-5900774e87a4.html.

344. Hays and Watts, "Best April Fools' Hoax."

345. Kris Worrell, "Wnor Prank Explodes in Station's Face," DailyPress.com, last modified April 3, 1992, articles.dailypress.com/1992-04-02/news/9204020020_1_fcc-mount-trashmore-disc-jockeys.

346. Hays and Watts, "Best April Fools' Hoax."

347. Ibid.

348. "Listeners Criticize WNOR," *Daily Press*, April 3, 1992, C1.

349. Ibid., C2.

350. Hays and Watts, "Best April Fools' Hoax."

351. Kris Worrell, "5 WNOR Staffers Are Off the Air," *Daily Press*, April 4, 1992, C1.

352. "2-4-6-8, It's Arlo We Appreciate!," *Daily Press*, April 24, 1992, 2.

353. "Foolishness On the Air," *Daily Press*, April 4, 1992, A6.

354. Hays and Watts, "Best April Fools' Hoax."

355. Tony Gabriele and *Daily Press* staff, "The 1992 Toadies," *Daily Press*, December 27, 1992, G7.

356. "Worst Radio Station," *Daily Press*, January 8, 1993, Sec. In-Roads, 11.

357. Blattner and Nicholson, "Indicted Radio Personality," B3; Ken Armstrong, "Joke Costs 'The Bull,' WNOR99 $45,000," *Daily Press*, June 10, 1993, C1–C2.

358. Holtzclaw, 'Radio's 'Bad Boy' Del Toro Dies, 44."

359. King, "Tommy Announces He's Leaving."

RESOURCES

B elow is a selection of the resources used to compile the information presented in this book. For a detailed look at each resource, please reference the notes section.

Books

Bellant, Richard. *The Coors Connection: How Coors Family Philanthropy Undermines Democratic Pluralism*. New York: South End Press, 1999.

Burch, Brian, and Emily Stimpson. *The American Catholic Almanac: A Daily Reader of Patriots, Saints, Rogues, and Ordinary People Who Changed the United States*. Danvers, MA: Crown Publishing Group, 2017.

Campbell, Ballard C. *Disasters, Accidents, Crises in American History*. New York: Infobase Publishing, 2008.

Downing, Sarah. *On This Day in Norfolk, Virginia History*. Charleston, SC: The History Press, 2015.

Fairfax, Colita Nichols. *Hampton, Virginia*. Charleston, SC: Arcadia Publishing, 2005.

Falzini, Mark W. *Their Fifteen Minutes: Biographical Sketches of the Lindbergh Case*. Bloomington, IN: iUniverse Inc., 2008.

Falzini, Mark W., and James Davidson. *New Jersey's Lindbergh Kidnapping and Trial*. Charleston, SC: Arcadia Publishing, 2012.

Fisher, Jim. *The Lindbergh Case: The Story of Two Lives*. New Brunswick, NJ: Rutgers University Press, 1994.

Franscell, Ron. *Delivered from Evil: True Stories of Ordinary People Who Faced Monstrous Mass Killers and Survived*. Osceola, FL: Fair Winds Press, 2014.

Gardner, Lloyd. *The Case That Never Dies: The Lindbergh Kidnapping*. New Brunswick, NJ: Rutgers University Press, 2012.

Grizzard, Frank E., and D. Boyd Smith. *Jamestown Colony: A Political, Social, and Cultural History*. Santa Barbara, CA: ABC-CLIO, 2007.

Horn, James P. *A Land as God Made It: Jamestown and the Birth of America*. New York: Basic Books, 2005.

Kierner, Cynthia A. "Grace Sherwood: The Witch of Pungo." In Virginia Women: Their Lives and Times, vol. 1. Athens: University of Georgia Press, 2016.

Konstam, Angus. *Blackbeard's Last Fight: Pirate Hunting in North Carolina, 1718*. London: Osprey Publishing, 2014.

Lee, Robert Earl. *Blackbeard the Pirate: A Reappraisal of His Life and Times*. Durham, NC: John F. Blair Publishers, 1974.

Lindbergh, Anne Morrow. *Gift from the Sea*. New York: Pantheon Books, 1995.

Litwack, Leon F. *Trouble in Mind: Black Southerners in the Age of Jim Crow*. New York: Vintage Books, 1999.

Mallios, Seth. *The Deadly Politics of Giving Exchange and Violence at Ajacan, Roanoke, and Jamestown*. Tuscaloosa: University of Alabama Press, 2006.

Parramore, Thomas C., Peter C. Stewart and Tommy Bogger. *Norfolk: The First Four Centuries*. Charlottesville: University Press of Virginia, 2000.

Perry, Phyllis J. *Colorado Vanguards: Historic Trailblazers and Their Local Legacies*. Charleston, SC: The History Press, 2015.

Price, David A. *Love and Hate in Jamestown: John Smith, Pocahontas, and the Heart of a New Nation*. New York: Vintage Books, 2005.

Richter, William L. *Historical Dictionary of the Civil War and Reconstruction*. Lanham, MD: Scarecrow Press, 2012.

Sachsman, David B., S. Kittrell Rushing and Ray Morris, eds. *Words at War: The Civil War and American Journalism*. West Lafayette, IN: Purdue University Press, 2008.

Wagner, Heather Lehr. *Charles Lindbergh* (Famous Flyers). New York: Chelsea House Publisher, 2003.

Government and Academic Institutions

City of Hampton
City of Virginia Beach

City of Virginia Beach Department of Tourism
Commonwealth of Virginia Department of Health
Department of Military and Veterans Affairs
Federal Bureau of Investigation
Hampton University
Library of Congress
Library of Virginia
National Archives and Records Administration (NARA)
United States Bureau of the Census
United States House of Representatives
United States Office of the Historian
United States Office of the Secretary of War
University of Chicago
University of North Carolina
University of Richmond
U.S. Coast Guard Department of the Historian
U.S. National Park Service

Interview

Dawn K. Midkiff, Grafton, VA. January 31, 2018.

Journals

Colonial Williamsburg Journal (Fall 1992 and Winter 2007).
Ideation: A Journal of William & Mary College Scholarship & Research (October 2011).
Pomona College Magazine (October 4, 2011).
Union Signal 44, no. 9.
Western Druggist 24, no. 11.
William & Mary Quarterly 68, no. 1.

Magazines

Coastal Virginia Magazine (January 2015).
Smithsonian Magazine (April 30, 2013).
Time.com

Media

Critical Past
Huffington Post
National Geographic News
NOVA (WGBH-Boston)
Public Broadcasting Service
Reuters.com
TODAY.com
WAVY-TV
WTKR.com

Newspapers

Akron Beacon Journal (Akron, OH)
Albuquerque Journal (Albuquerque, NM)
Alexandria Gazette (Alexandria, VA)
Almanack Gleaner (Graham, NC)
Baltimore Sun (Baltimore, MD)
Bee (Danville, VA)
Bradford Evening Star and the *Bradford Daily Record* (Bradford, PA)
Brooklyn Evening Star (New York, NY)
Cincinnati Enquirer (Cincinnati, OH)
Courier (Waterloo, IA)
Daily Exchange (Baltimore, MD)
Daily Press (Newport News, VA)
Fort Lauderdale News (Fort Lauderdale, FL)
Green Bay Press-Gazette (Green Bay, WI)
Hope Star (Hope, AR)
Indianapolis Star (Indianapolis, IN)
Ithaca Journal (Ithaca, NY)
Kane Republican (Kane, PA)
Louisville Daily (Louisville, KY)
Miami News (Miami, FL)
New Castle News (New Castle, PA)
News-Herald (Franklin, PA)
News Leader (Staunton, VA)
New York Times (New York, NY)

Peninsula Enterprise (Accomack, VA)
Pensacola News Journal (Pensacola, FL)
Pittsburgh Press (Pittsburgh, PA)
Reno Gazette Journal (Reno, NV)
Richmond Dispatch (Richmond, VA)
Scranton Republican (Scranton, PA)
Simpson's Leader-Times (Kittanning, PA)
Stark County Democrat (Canton, OH)
St. Louis Star (St. Louis, MO)
Tallahassee Democrat (Tallahassee, FL)
Tampa Bay Times (Tampa, FL)
Times-Dispatch (Richmond, VA)
Virginian-Pilot (Norfolk, VA)
Warren Times Mirror (Warren, PA)
Weekly Advertiser (Montgomery, AL)

Organizations

Chrysler Museum of Art
Civil War Trust
Contraband Historical Society of Hampton
Ferry Plantation House: A Historic Site in Virginia Beach, Virginia
German Genealogical Group of New York City
Golden History Museum
Hampton History Museum
Italian Genealogical Group of New York City
Jamestown Rediscovery Project
Jamestown Settlement and American Revolution Museum at Yorktown
The Mariners' Museum and Park
Newport News Shipbuilding Apprentice School Organization
North Carolina History Project
Rocky Mountain Depression Glass Society
Virginia Historical Society

RESOURCES

Thesis

Hall, James E. "Black and White: A Historical Examination of Lynching Coverage and Editorial Impact in Select Virginia Newspapers." Master's thesis, Virginia Commonwealth University, 2001.

Websites and Blogs

Ancestry.com. www.ancestry.com.
Blackbeard's Realm. blackbeardsrealm.com.
Cavalier Hotel. www.cavalierhotel.com.
Colorado Virtual Library. www.coloradovirtuallibrary.org.
Encyclopedia Virginia. www.encyclopediavirginia.org.
Find-a-Grave.com. www.findagrave.com.
Fredericksburg.com. www.fredericksburg.com.
The Historical Marker Database. www.hmdb.org.
The Lindbergh Kidnapping Hoax. www.lindberghkidnappinghoax.com.
Making History: Presented by Colonial Williamsburg (blog). makinghistorynow.com.
Notable Names Database. www.nndb.com.
Notes from the Bunker (blog). commandzero.com.
Oxford Research Encyclopedia of American History Online. americanhistory.oxfordre.com.
U.S. Mission Trail. www.usmissiontrail.com.
YouTube.com. www.youtube.com.